To Judy & Dave ~
our dear friends and
cousins, in remembrance
of a wonderful day. 10/27/12

Elise & Jack

America THE *Beautiful*
BOSTON

JORDAN WOREK

Photographs by BILL HORSMAN

FIREFLY BOOKS

A FIREFLY BOOK

Published by Firefly Books Ltd. 2010

First printing

Publisher Cataloging-in-Publication Data (U.S.)

Worek, Jordan.
 Boston / Jordan Worek ; Bill Horsman Photography.
[] p. : col. photos. ; cm. America the Beautiful series.
Summary: Captioned photographs showcase the remarkable architecture,
dynamic neighborhoods and exciting attractions of Boston.
ISBN-13: 978-1-55407-591-1 ISBN-10:1-55407-591-2
1. Boston (Mass.) – Pictorial works. 2. Boston (Mass.) – Buildings, structures, etc. –
Pictorial works. I. Horsman, Bill, ill. II. America the Beautiful / Dan Liebman. III. Title.
974.461 dc22 F73.37W67 2010

Published in the United States by
Firefly Books (U.S.) Inc.
P.O. Box 1338, Ellicott Station
Buffalo, New York 14205

Published in Canada by
Firefly Books Ltd.
66 Leek Crescent
Richmond Hill, Ontario L4B 1H1

Cover and interior design: Kimberley Young

Printed in China

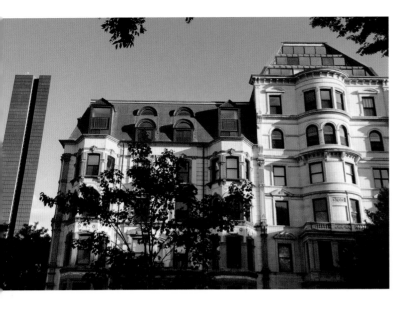

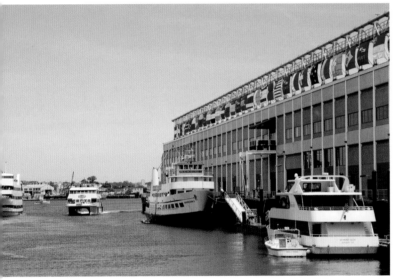

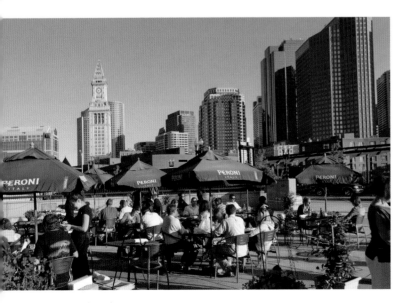

BOSTON is a city of firsts. Boston Common is America's first public park. The city's post office and public library were also the first in the United States. Harvard, whose graduates include six U.S. Presidents, is the oldest university in the country. And, yes, the Boston Red Sox played in – and won – the first World Series at the venerable Fenway Park, the oldest baseball stadium in Major League Baseball.

Known as the birthplace of the American Revolution, Boston was founded in 1630 by Puritan colonists, about 150 years before the 13 colonies formed a new nation. Because of the city's prominent role in the Revolution, many important historic sites have been preserved. The Freedom Trail covers 16 landmarks that commemorate the country's early struggle for freedom. What makes these places unique is that they are not re-creations.

And that's what's wonderful about Boston. It's a city where history is alive wherever you walk – where the patriots convened at Faneuil Hall which, by the way, is pronounced "Fan-yule."

Speaking of pronunciation, Boston is also known as the city where locals drop their Rs. *Chowdah* is chowder. And you may hear someone telling you to "pack ya cah in Havud Yad."

But Boston is more than history. It is an educational center and a city of great neighborhoods, museums, shopping, dining and sports. The atmosphere at Fenway Park is unmatched anywhere. The same could be said of Boston and Bostonians.

From its elegant old homes to its modern-day towers, from its oldest neighborhoods to its contemporary streetscapes, the city offers an abundance of treasures. We hope you'll enjoy them all as you travel the pages of *America the Beautiful – Boston.*

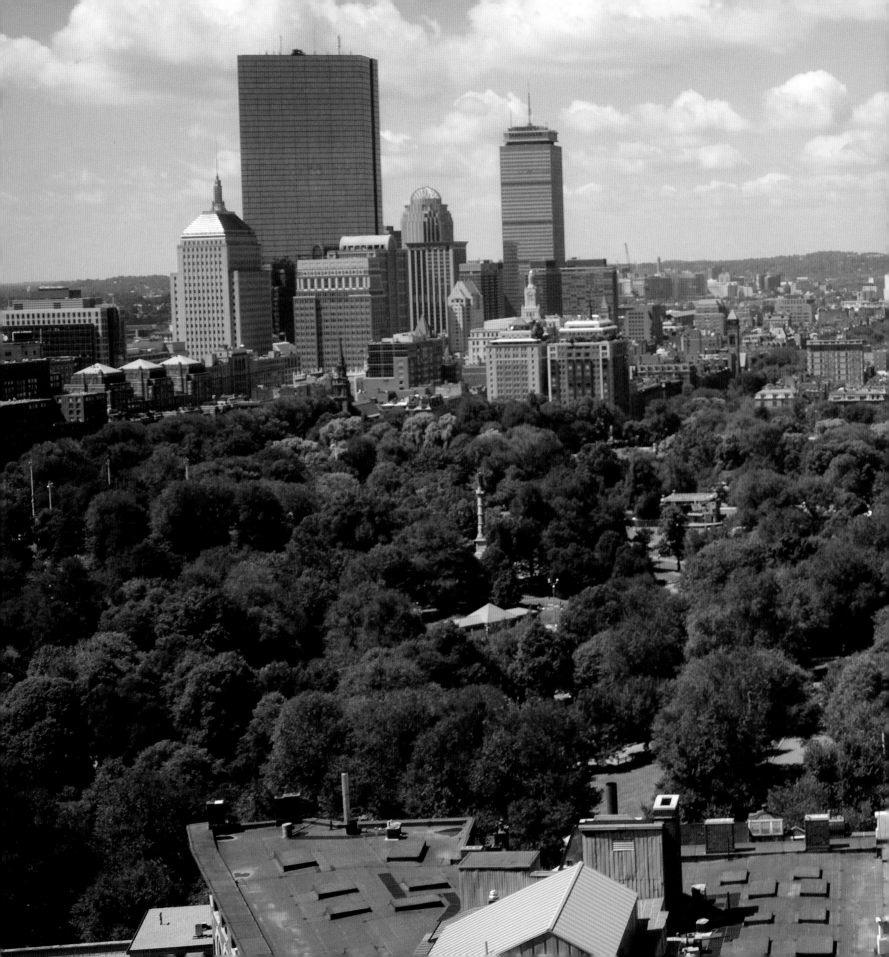

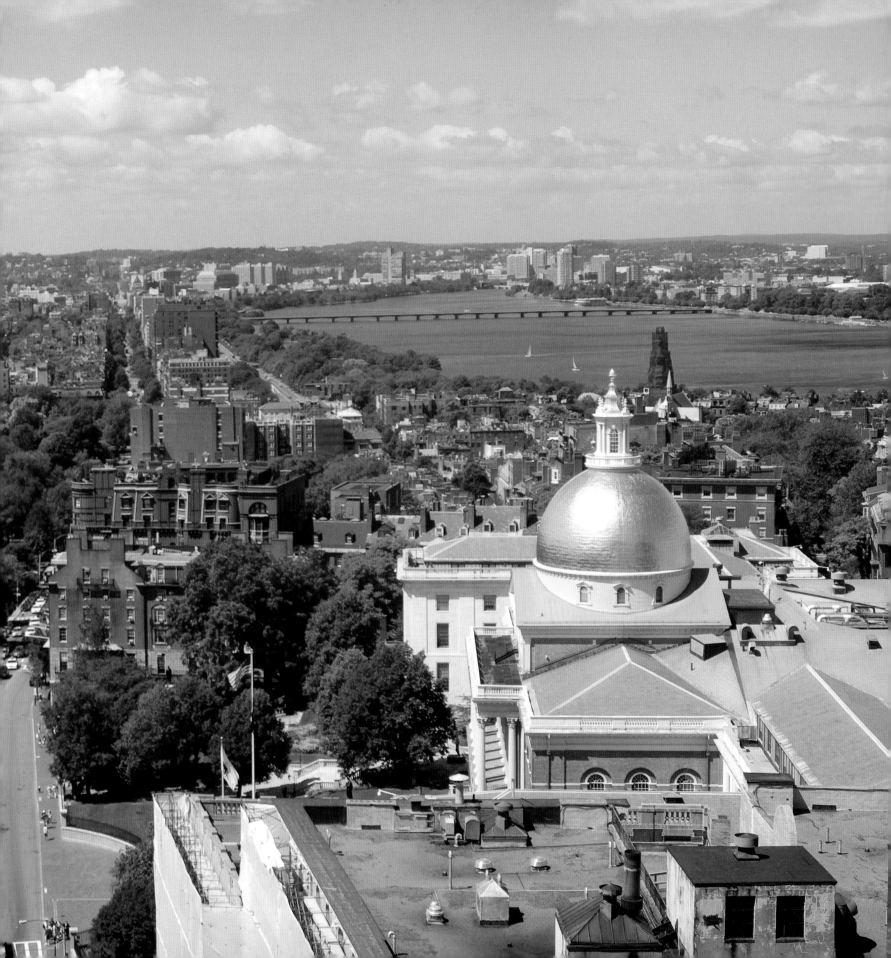

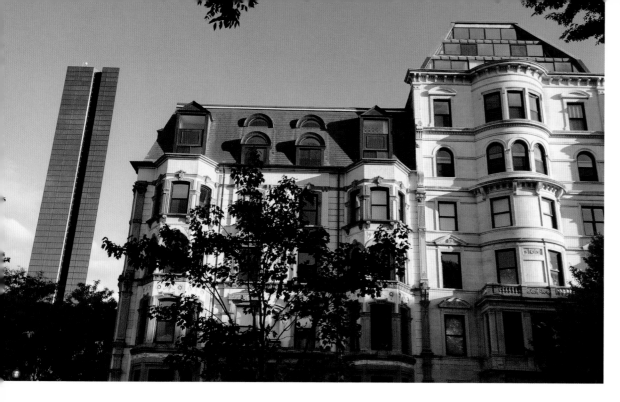

The contrast between old and new architectural styles in Back Bay is often dramatic. The John Hancock Tower, the tallest building in New England, is seen in the background, and an ornate Victorian apartment building on Commonwealth Avenue appears in the foreground. Commonwealth Avenue, along with Newbury and Boylston Streets, are the main arteries of the Back Bay community.

OPPOSITE PAGE: Cobblestoned Acorn Street, built up in the 1820s, is typical of Beacon Hill, known for its Federal-style rowhouses, gas street lanterns and brick sidewalks. In addition to historic homes, the Massachusetts State House, Suffolk University and Park Street Church are all found in Beacon Hill.

PREVIOUS PAGE: Boston was situated on a narrow peninsula until the 1850s, when projects began to fill in the surrounding tidal marshes. By 1880 this work was complete, and French-inspired neighborhoods with elegant boulevards began to spring up. The highly desirable Back Bay area is dominated by Victorian brownstones to the north and by some of the city's tallest skyscrapers to the south. The golden-domed State House appears in the foreground.

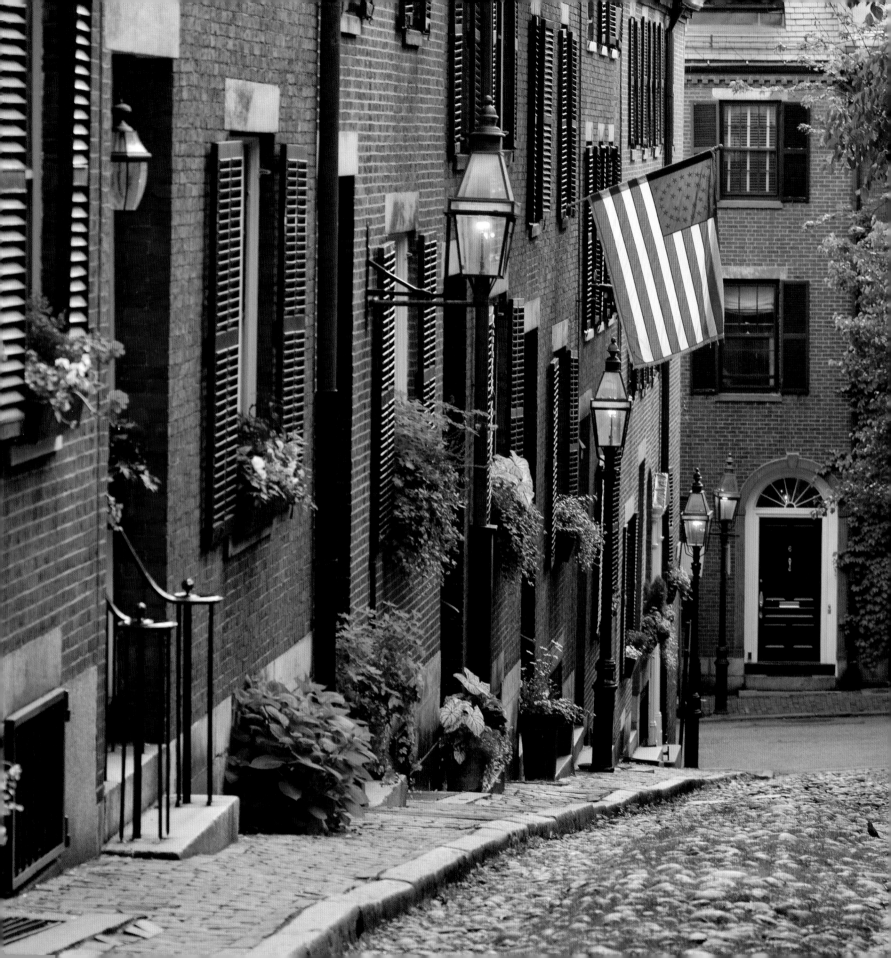

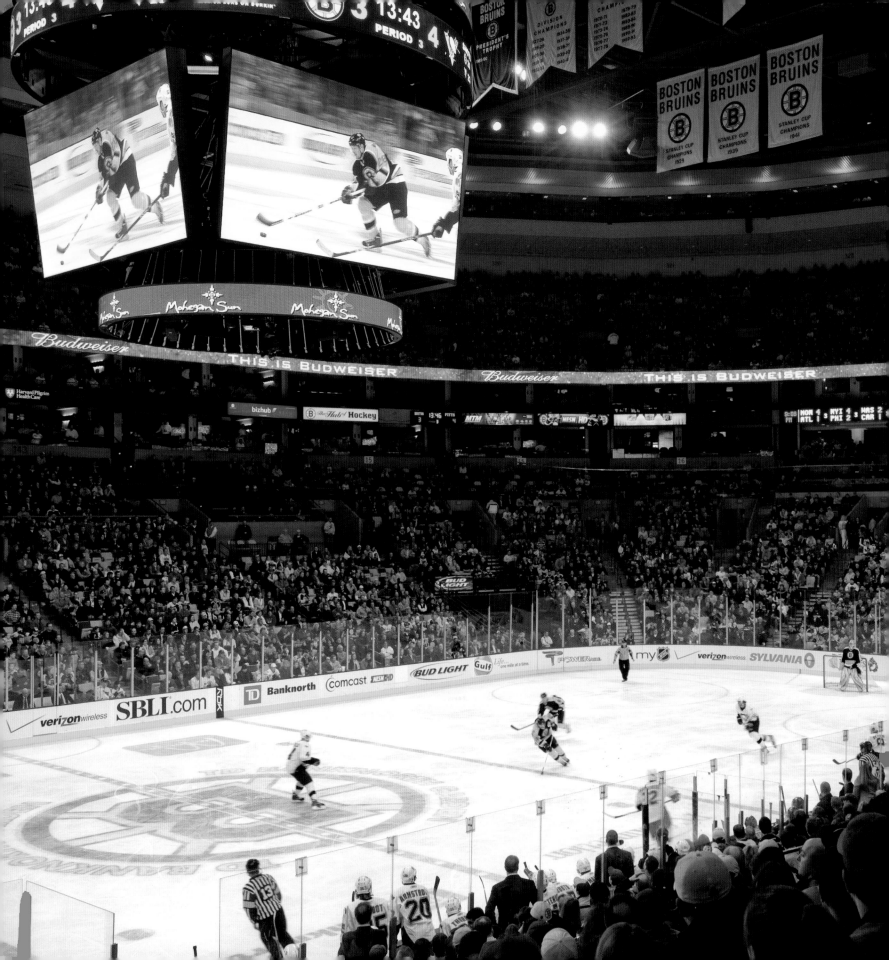

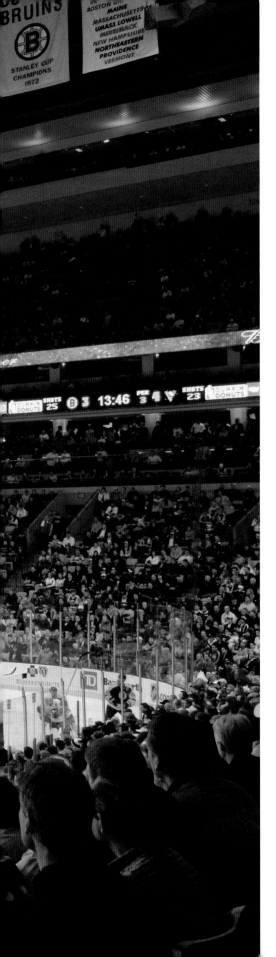

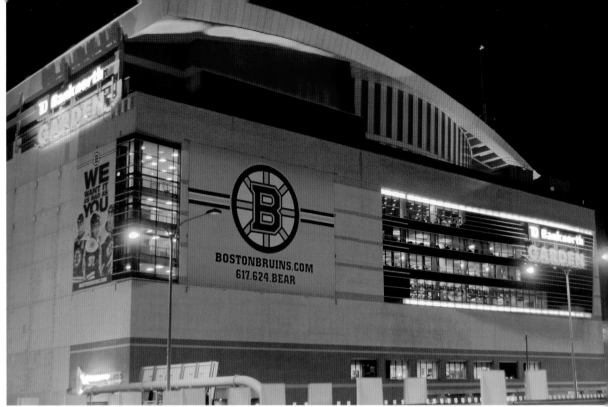

In 1928, President Calvin Coolidge officially switched on the lights for the first time at the original Boston Garden by turning a gold key in the White House. This feat, employing the newest telegraph technology of the time, is mirrored today in technological and structural advances at the new TD Banknorth Garden, which opened in 1995 to replace the aging original structure.

OPPOSITE PAGE: TD Banknorth Garden is host to music's hottest stars as well as to sports heroes. Both the Boston Bruins, seen here battling the Pittsburgh Penguins, and the Boston Celtics call this 19,600-seat arena home.

FOLLOWING PAGE: Boston Common, seen here from the Ritz-Carlton Hotel on Avery Street, dates from 1634 and is one of the oldest parks in the United States. The 50-acre oasis was once the setting of public hangings. More recently, it has been the site of large outdoor concerts and many important speeches, including those by Martin Luther King Jr. and Pope John Paul II.

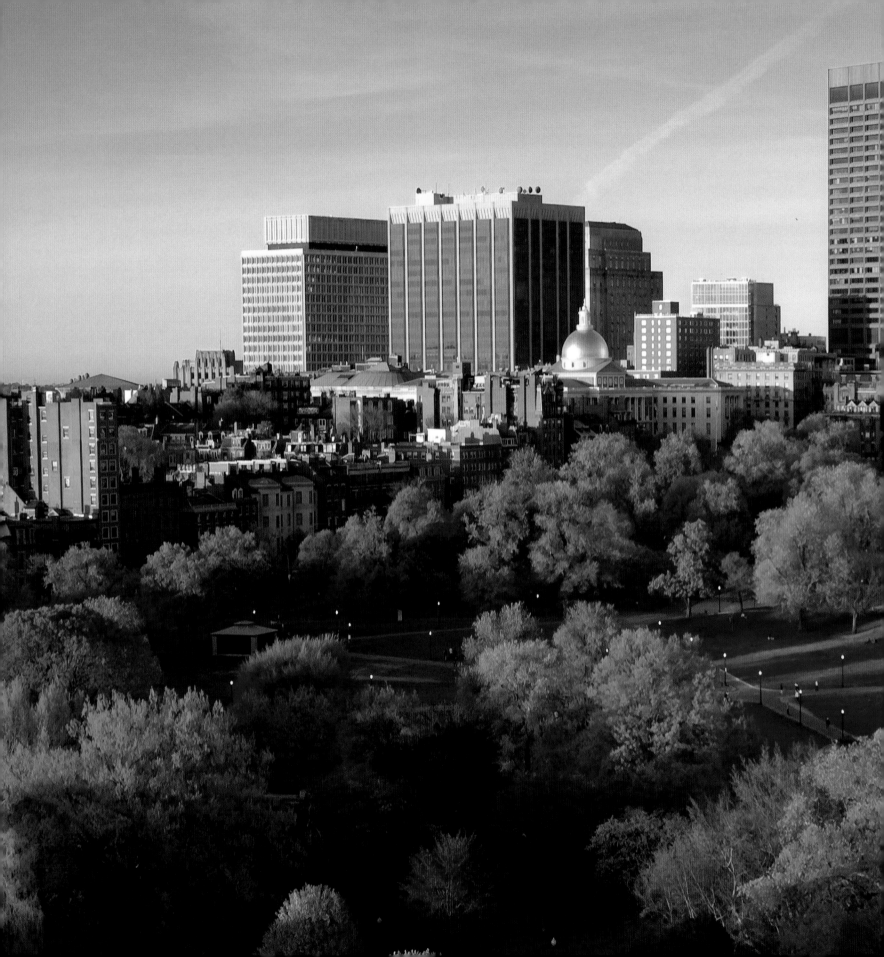

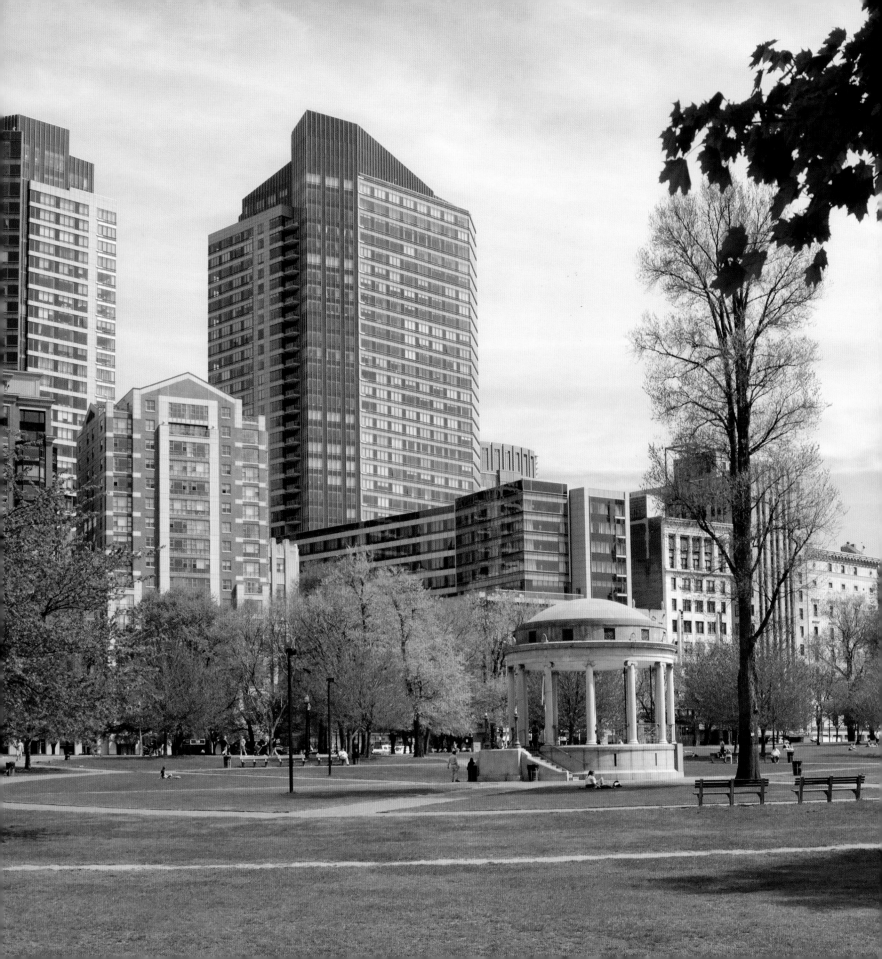

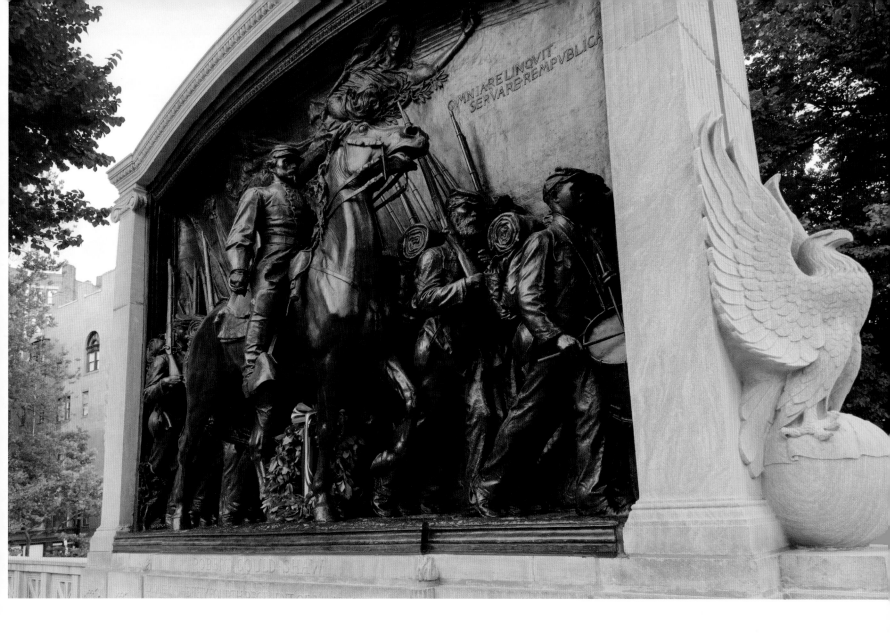

Across from the State House in Boston Common stands the fine bronze Shaw Memorial. The memorial commemorates the 54th regiment of Massachusetts Infantry, which fought in the Civil War. This was the first free Black regiment to fight for the Union Army, and its heroic story was told in the 1989 film *Glory*.

OPPOSITE PAGE: Boston Common is bordered by Boylston Street, Charles Street, Beacon Street, Park Street and Tremont Street, making it a central meeting place for the city. Among the park's notable features is the Parkman Bandstand, built to honor George F. Parkman who donated $5 million toward the upkeep of the city's parks.

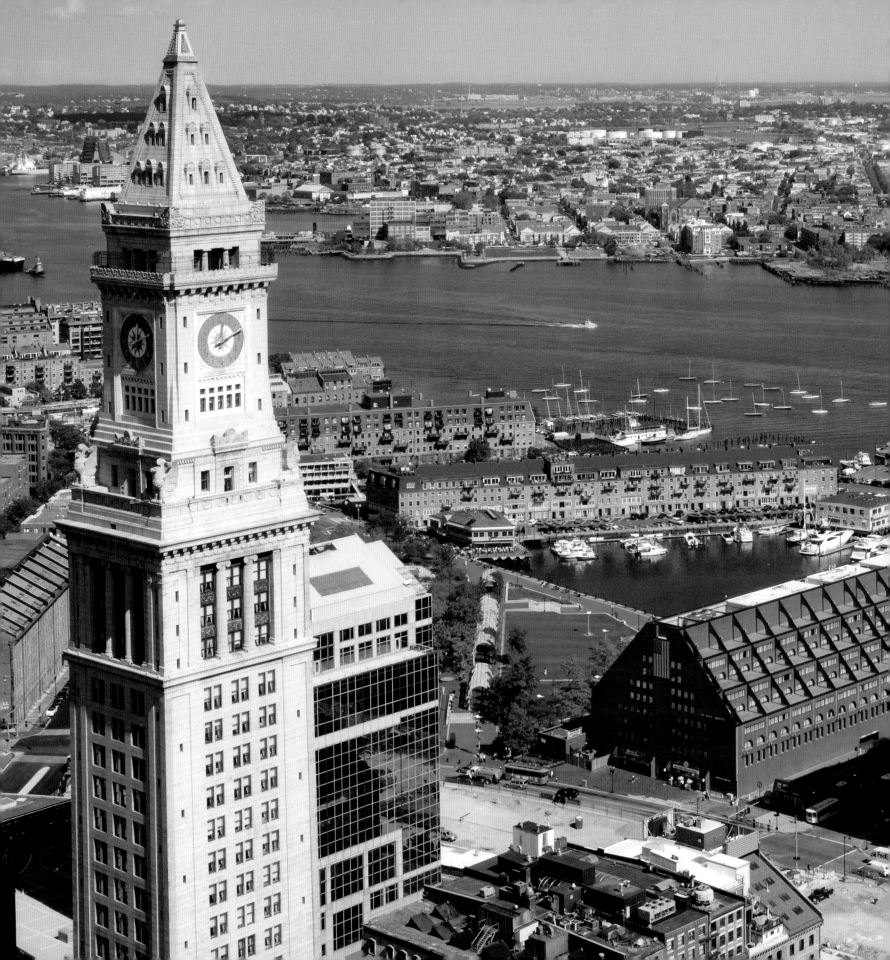

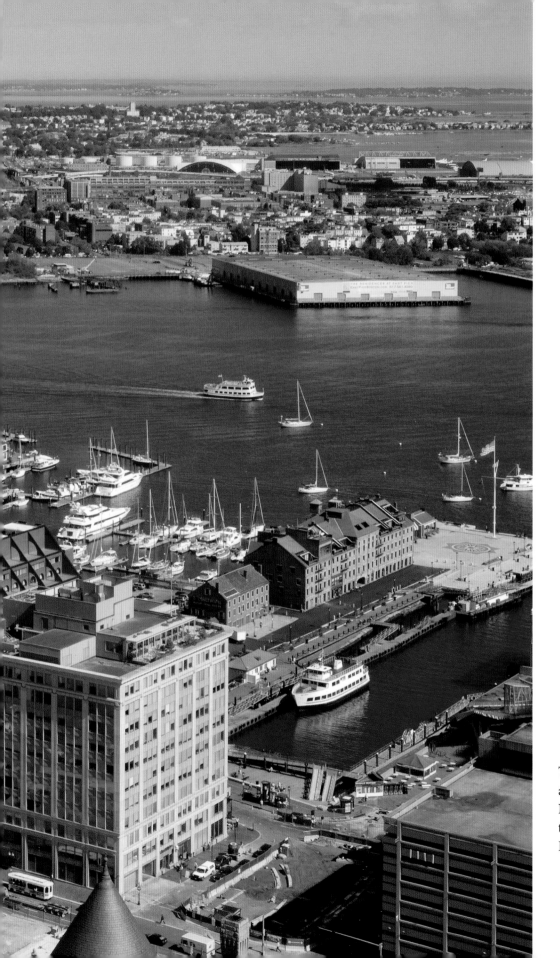

The Custom House Tower stands proudly above the Port of Boston and Boston Harbor. Now a major northeastern shipping facility, this natural harbor was the site of the Boston Tea Party.

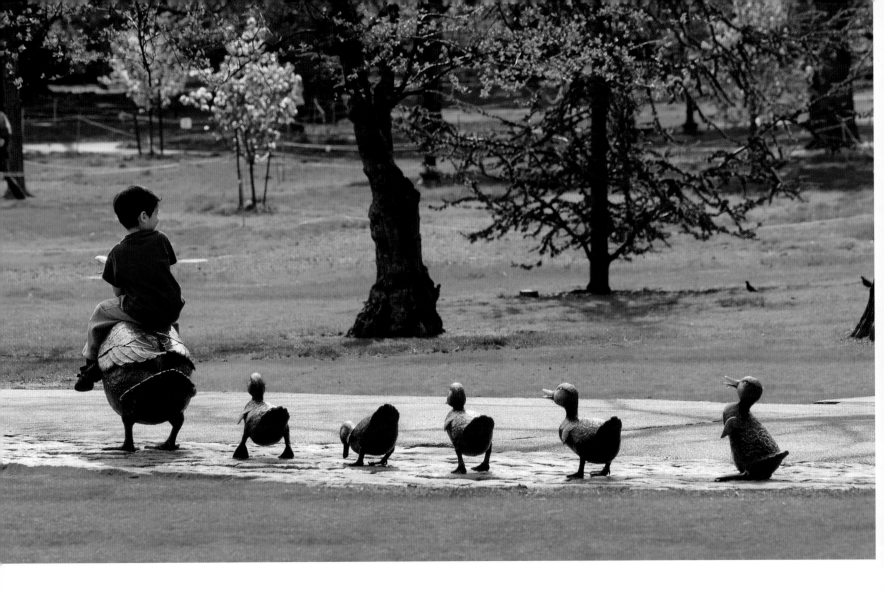

These bronze statues of a mother duck and her babies are based on the popular book *Make Way for Ducklings*. Published in 1941, the perennial best-seller tells the story of a pair of mallard ducks who decide to nest and raise a family on an island in the lagoon at the Boston Public Gardens.

OPPOSITE PAGE: The 24-acre Boston Public Garden, designed in the English style, is both smaller and more formal than its neighbor, Boston Common. In addition to its various monuments, the garden features an artificial lagoon and ornamental bridge. Since the 1870s, swan boats have glided over the waters to the delight of locals and tourists.

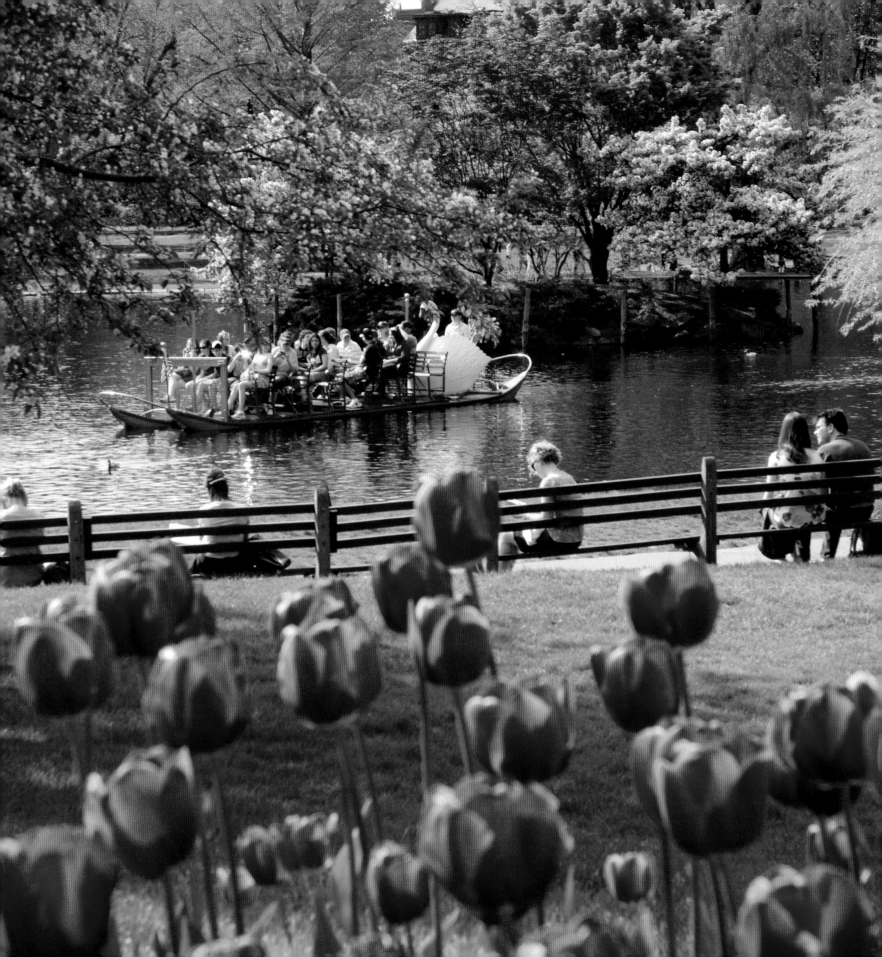

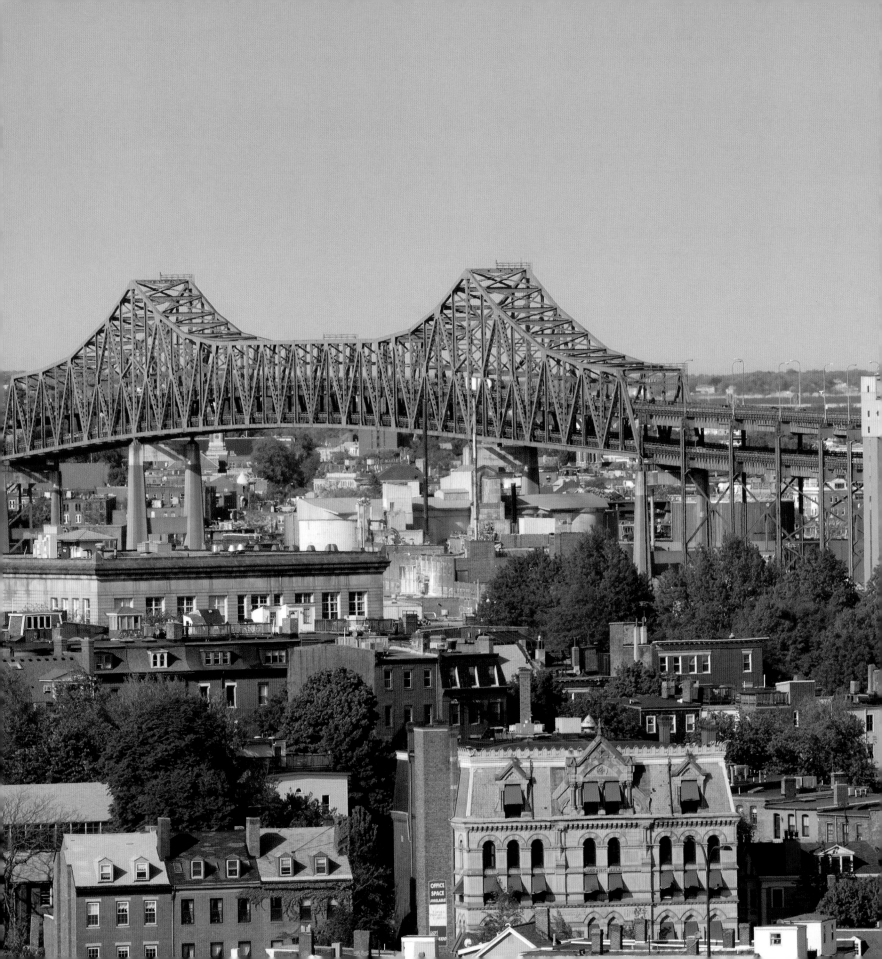

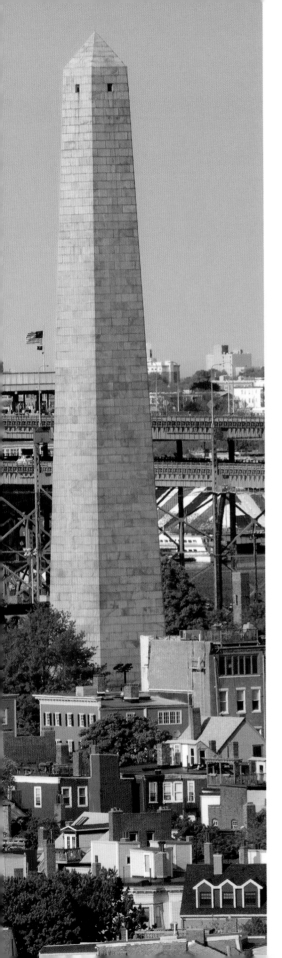

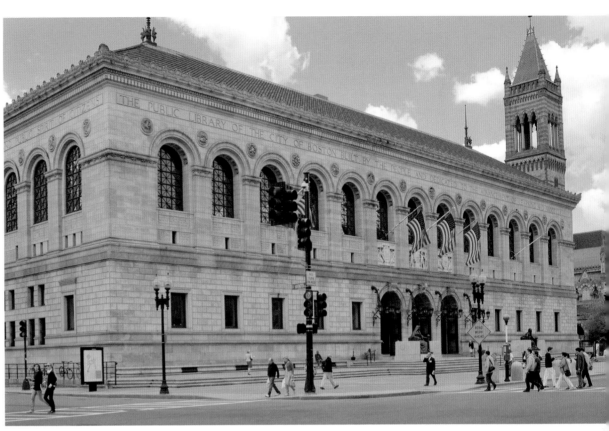

The Boston Public Library was the nation's first public metropolitan library. Quickly outgrowing its original structure, this large Italian palazzo-style building on Copley Square was constructed between 1887 and 1895. Its many architectural features include the soaring barrel-vaulted ceiling of Bates Hall and the proud words "Free to All" emblazoned above the entrance doors.

OPPOSITE PAGE: Seen here are the Bunker Hill Monument and the Tobin Memorial Bridge. The bridge spans more than two miles over the Mystic River from Charlestown to Chelsea, making it the longest in New England. The granite obelisk commemorates the Battle of Bunker Hill and was completed in 1842, replacing a much smaller pillar put up in 1794 to honor Dr. Joseph Warren, a Revolutionary leader.

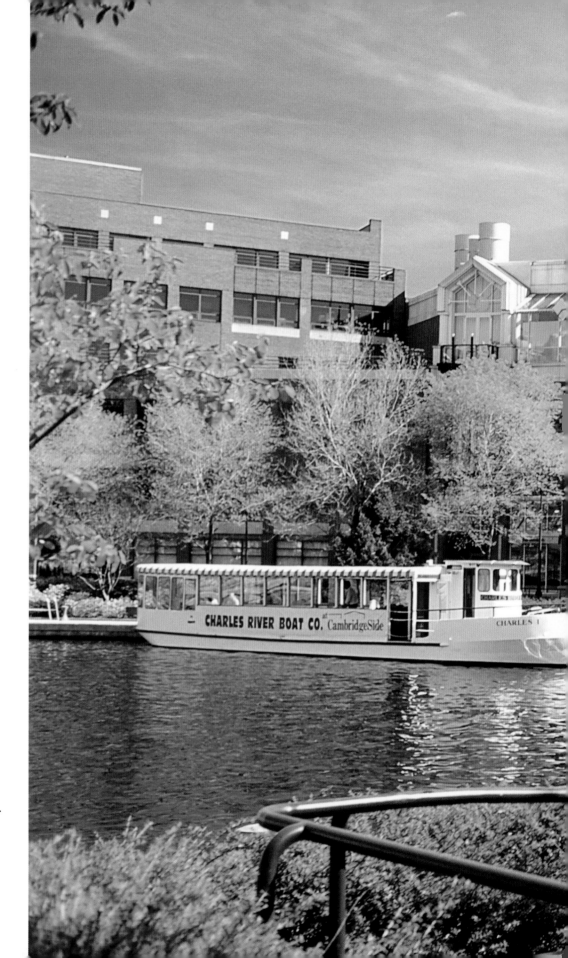

The CambridgeSide Galleria, located near the Museum of Science, was built in 1990 along the Lechmere Canal off the Charles River. It is the only mall in the Greater Boston area that boasts direct access by boat. Here a Charles River Boat Company shuttle waits to ferry passengers.

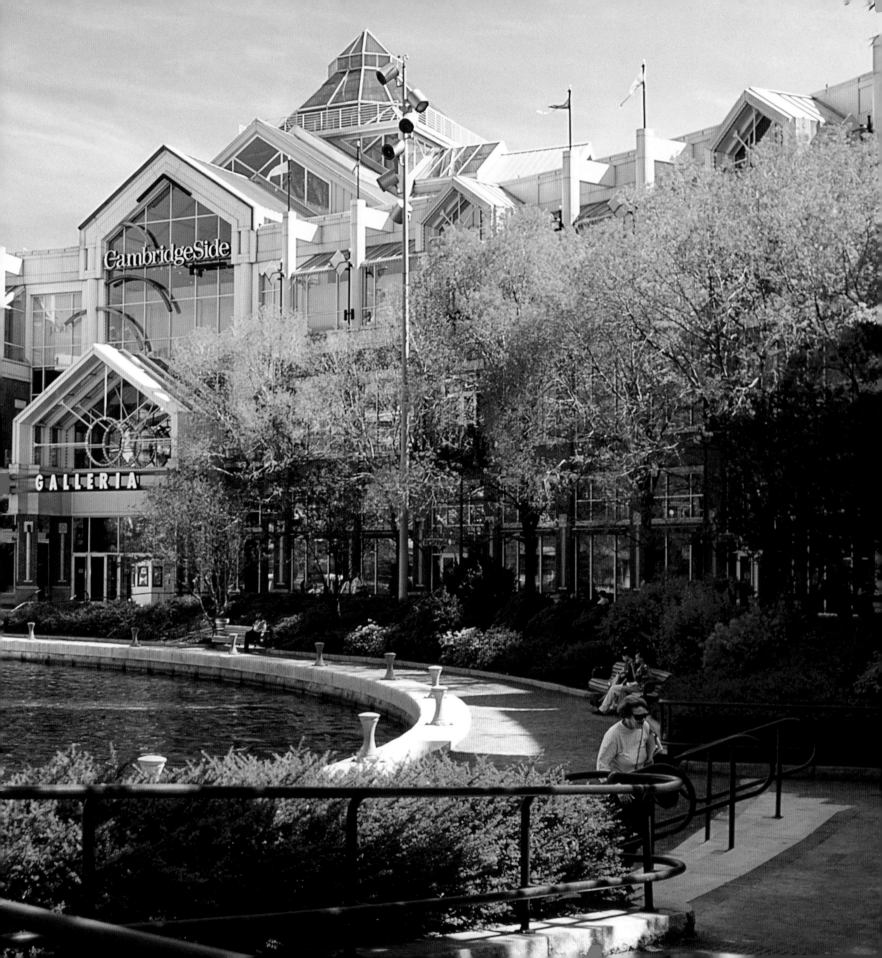

Although we often think of cities as specifically built for and solely occupied by humans, a host of wildlife find a way to live among us. This Great Blue Heron, surely a welcome sight to many work-weary joggers, is searching for its next meal in the shallow waters along the Esplanade.

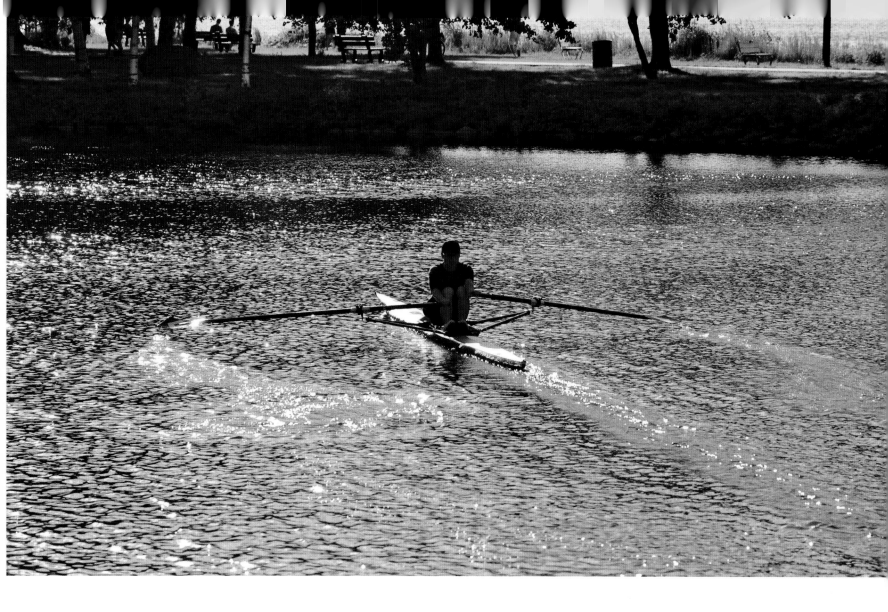

Rowing has a long history on the Charles and Mystic Rivers, thanks in large part to the influence of Harvard University and the Massachusetts Institute of Technology. There are also many clubs for those not part of an academic team. Kayaking, canoeing and sailing are other popular ways to enjoy the Boston waterways.

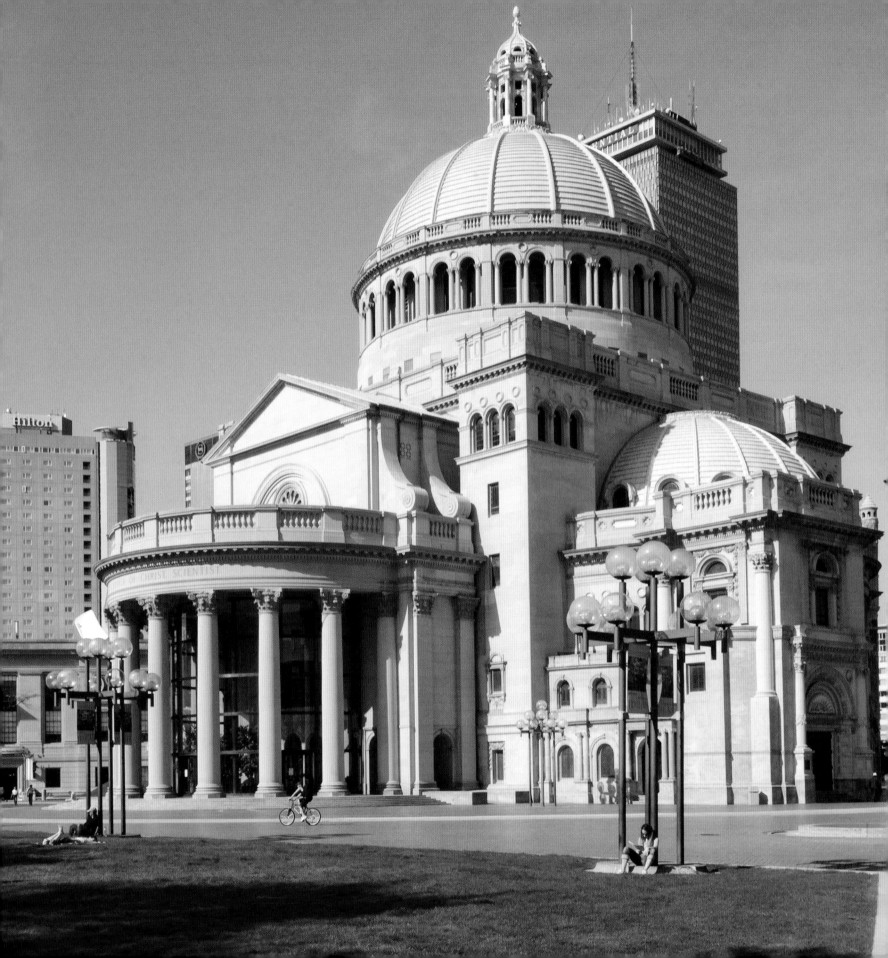

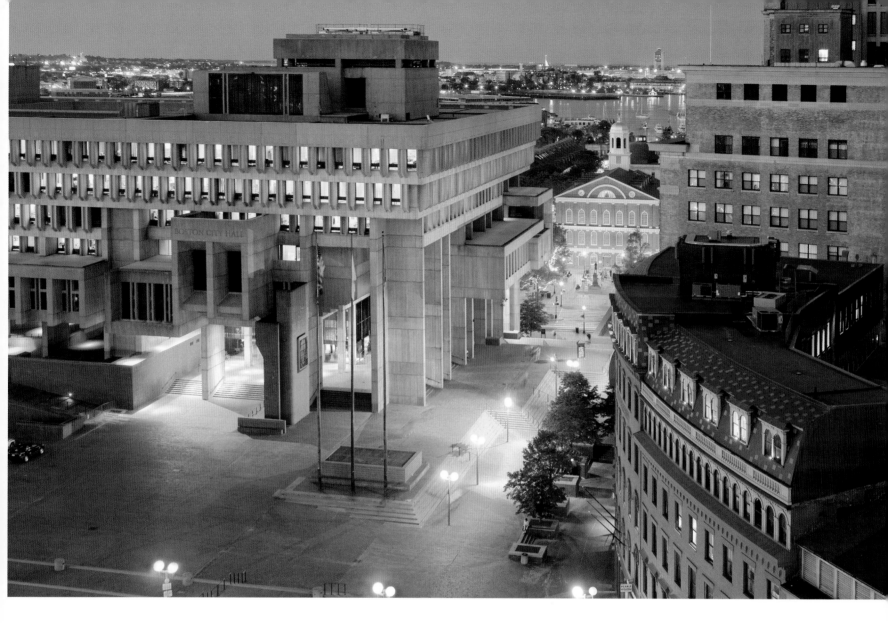

Designed in 1962, the City Hall Plaza has received mixed reviews, but is a central meeting place in the Government Center area of downtown.

OPPOSITE PAGE: This grand Romanesque structure is part of the world headquarters of the First Church of Christ, Scientist, which occupies a 14-acre site at the corner of Huntington and Massachusetts Avenues. Built in 1894, the domed building is actually only a chapel; a much larger basilica was built nearby in 1906.

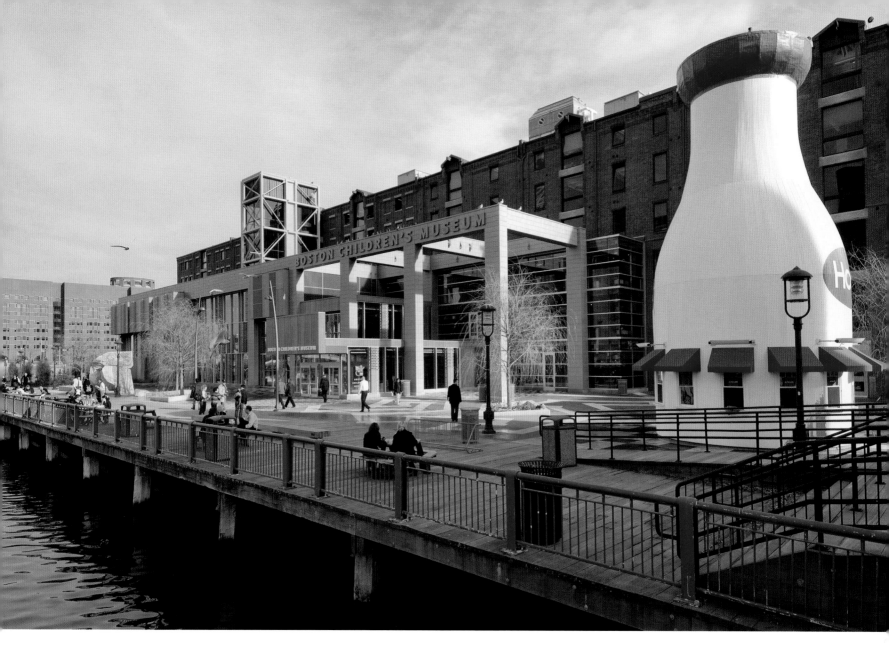

The Boston Children's Museum was founded in 1913 by several teachers in the Jamaica Plain neighborhood and has always featured a hands-on approach. Children here are free to interact with and explore exciting exhibits on such subjects as science, art and social responsibility.

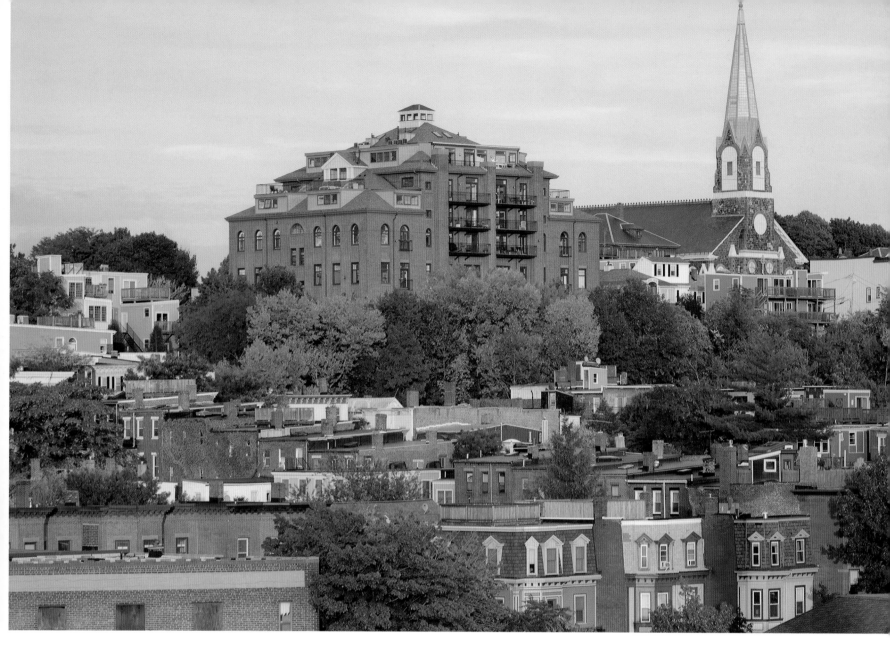

Charlestown, located on the north bank of the Charles River, is a community full of history. Founded in 1628 as an English Puritan village, Charlestown witnessed the Battle of Bunker Hill. It was also the place from which Paul Revere began his "midnight ride" and where the USS *Constitution*, the oldest commissioned vessel in the United States Navy, is docked.

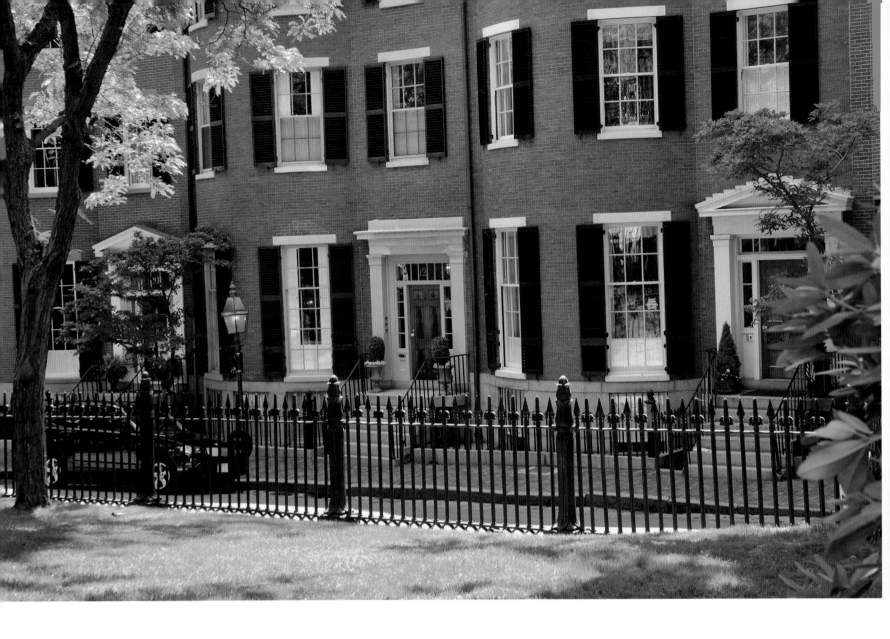

Boston is known as a city of neighborhoods. Charlestown (right), with its colonial architecture, was the first capital of the Massachusetts Colony before being annexed by Boston. Beacon Hill (above), just north of the Boston Common, is celebrated for its Federal-style row houses and narrow streets. Because of their historic charm and proximity to downtown, both residential areas are considered highly desirable.

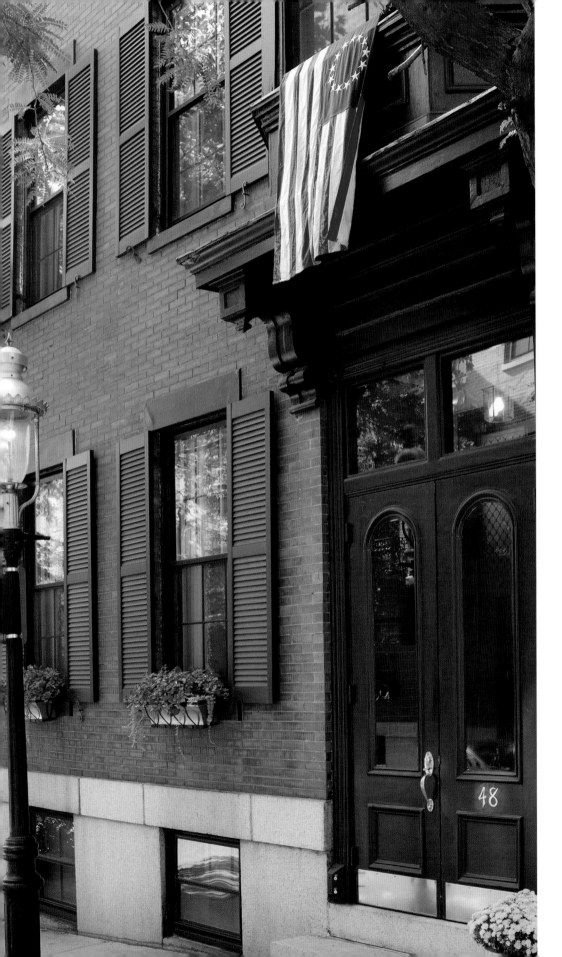

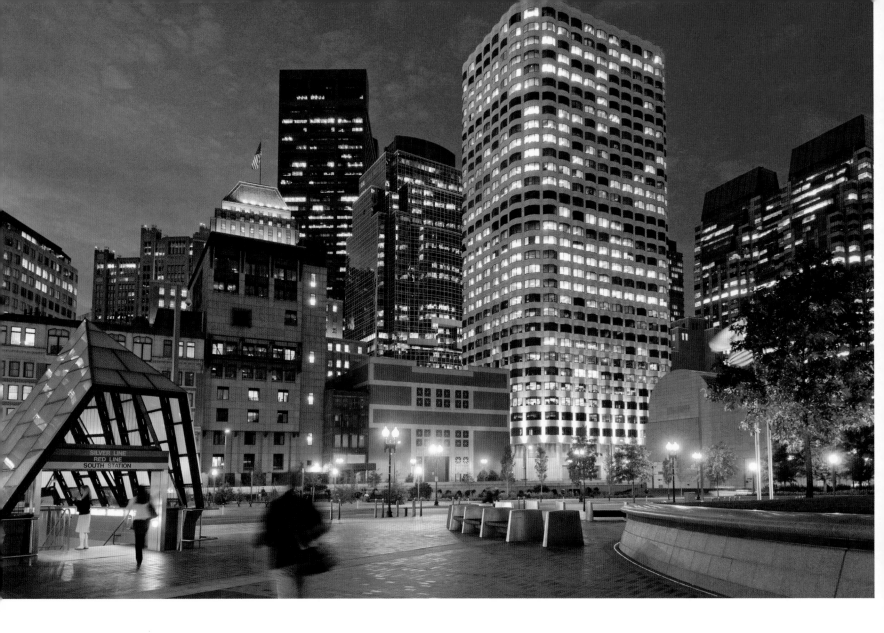

This quiet night scene depicts 99 High Street as viewed from South Station. The distinctively white 32-story skyscraper was built in 1971 and renovated in 1995, changing hands several times since during various real estate frenzies.

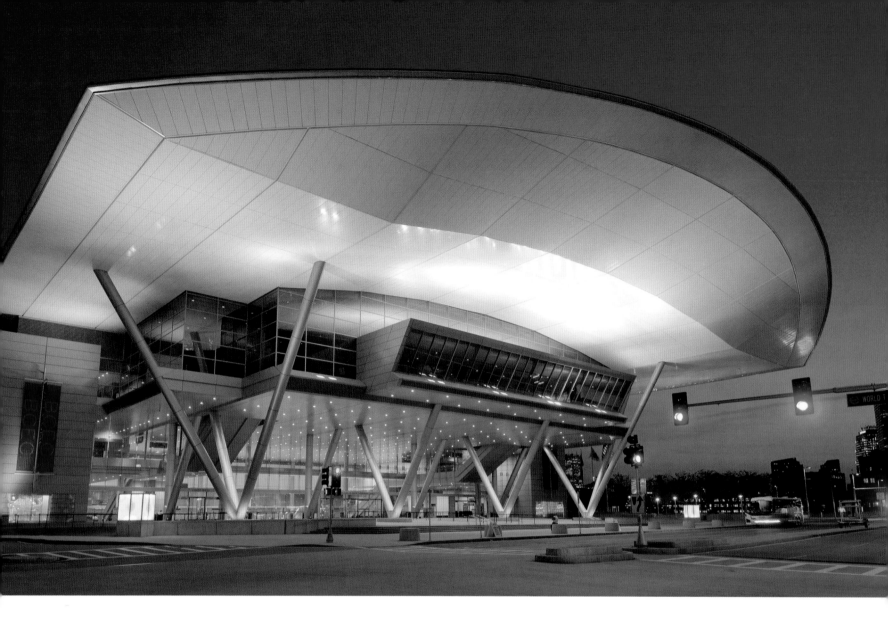

The Boston Convention and Exhibition Center is a $700 million, 516,000-square-foot facility completed in 2004 as part of a major effort to rejuvenate the Seaport District. This massive site was home to the city's wool industry until the 1950s, then grew derelict. Today, new high-rise hotels, luxury condos and a subway line, along with the dramatic convention center, have been responsible for the area's renewal.

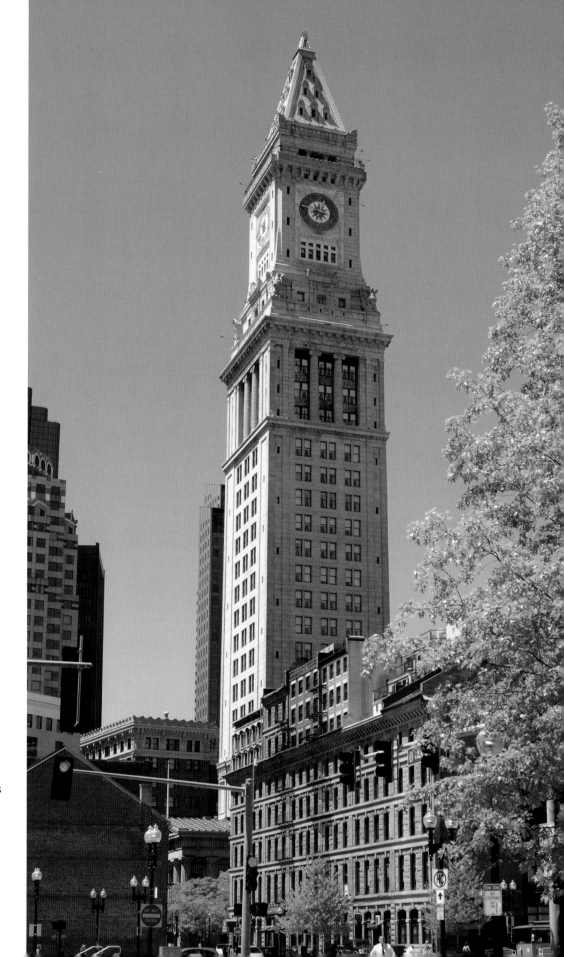

Boston's original Custom House, designed in the Greek Revival style with Doric columns and domed roof, was completed in the mid-19th century. Its familiar 496-foot tower, however, was not added to the base until 1913. In the late 1980s, customs officials moved and the building became unoccupied before being transformed into a Marriott Vacation Resort.

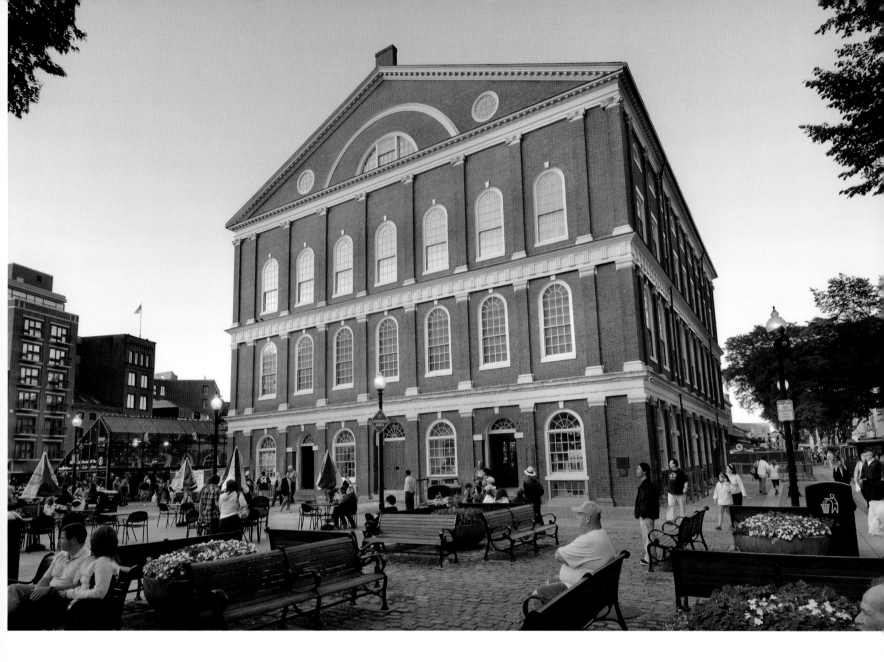

Faneuil Hall has functioned both as a town meeting place and as a public market since its wealthiest merchant, Peter Faneuil, gave it to the city of Boston in 1742. The Georgian brick landmark has provided a platform for many of the nation's greatest orators. It was here that colonists first protested the *Sugar Act* of 1764, establishing the doctrine of "no taxation without representation."

The Hatch Shell is a much-loved outdoor stage located on the Esplanade along the Charles River. With a large lawn spreading out before it, the Hatch Shell is a popular venue for concerts and many other events, including the Earth Day festival being celebrated here.

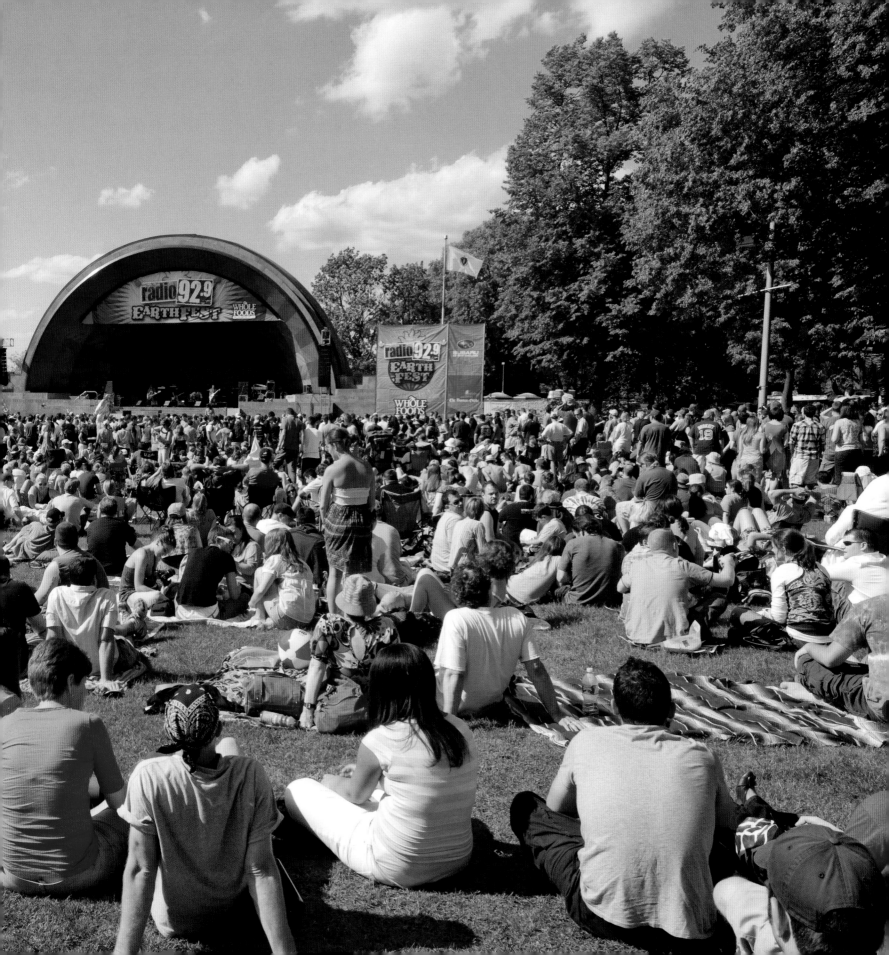

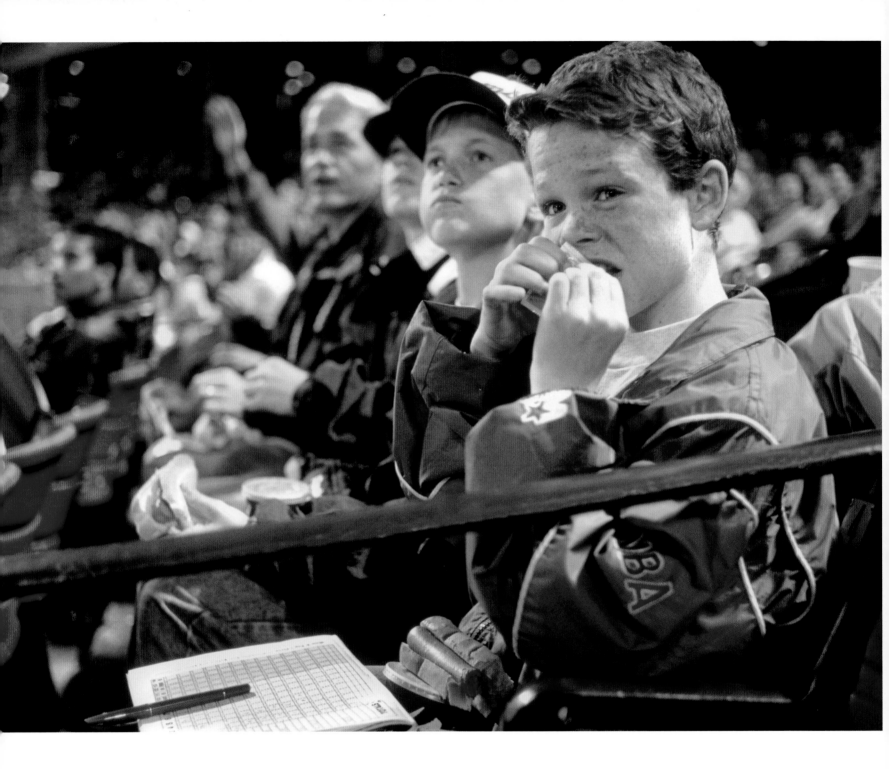

In what could be a scene from a Norman Rockwell painting, a group of young boys eagerly watch a game at Fenway Park, tracking the every move of their heroes, the Boston Red Sox. Like many other traditions, watching the game is a pastime often passed from generation to generation.

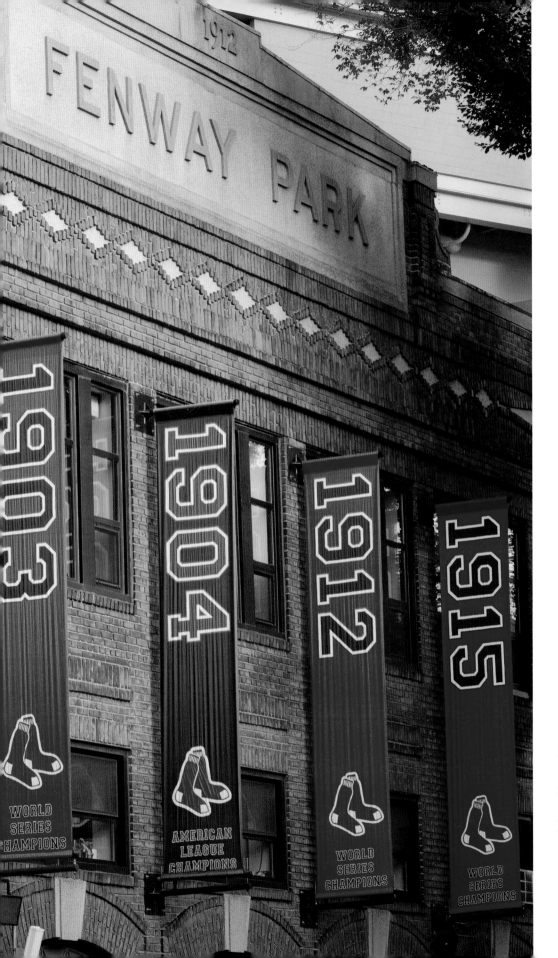

Banners commemorating the Boston Red Sox World Series Championships hang from the brick exterior of Fenway Park along Yawkey Way. The team had one of the longest droughts in history. After 1918, they did not win the Championship until 2004.

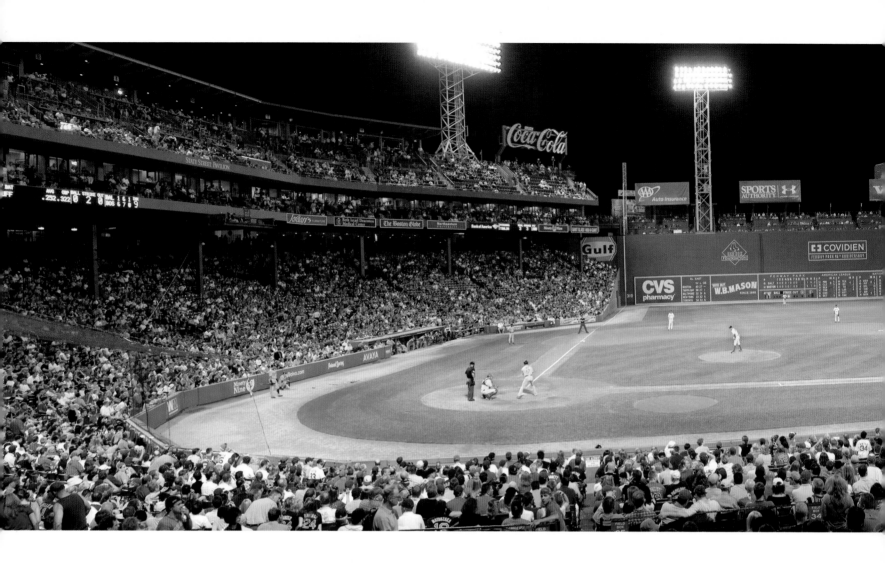

This panorama from section 16 of Fenway Park shows the Boston Red Sox playing before a full house in the early evening hours. The club was founded in 1901. Six years later, owner John I. Taylor settled on the name Red Stockings for his team. Before long, however, Red Sox was almost universally adopted, having been popularized by the press because the full name was too long for a newspaper's headlines.

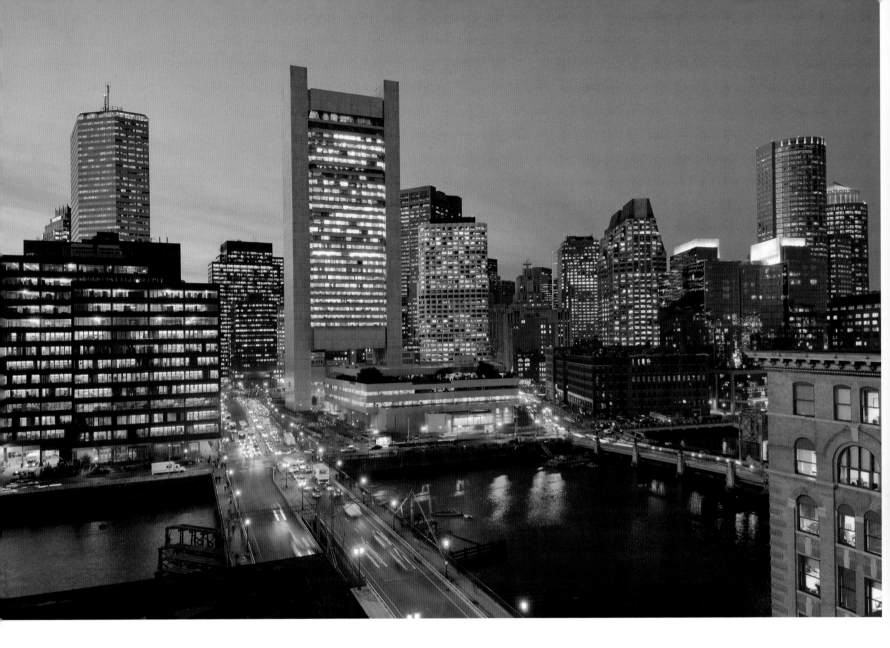

Boston's Financial District is seen here at dusk from Summer Street. Although it has no official boundaries or status, the Financial District is generally agreed to be bounded by Atlantic Avenue, State Street and Devonshire Street.

OPPOSITE PAGE: The slender column of the Custom House Tower rises above Boston's Financial District as dusk begins to set in. Once located in almost every major seaport but now often a historical anachronism, custom houses were occupied by city officials who managed the paperwork for the import and export of goods, collecting duties when appropriate.

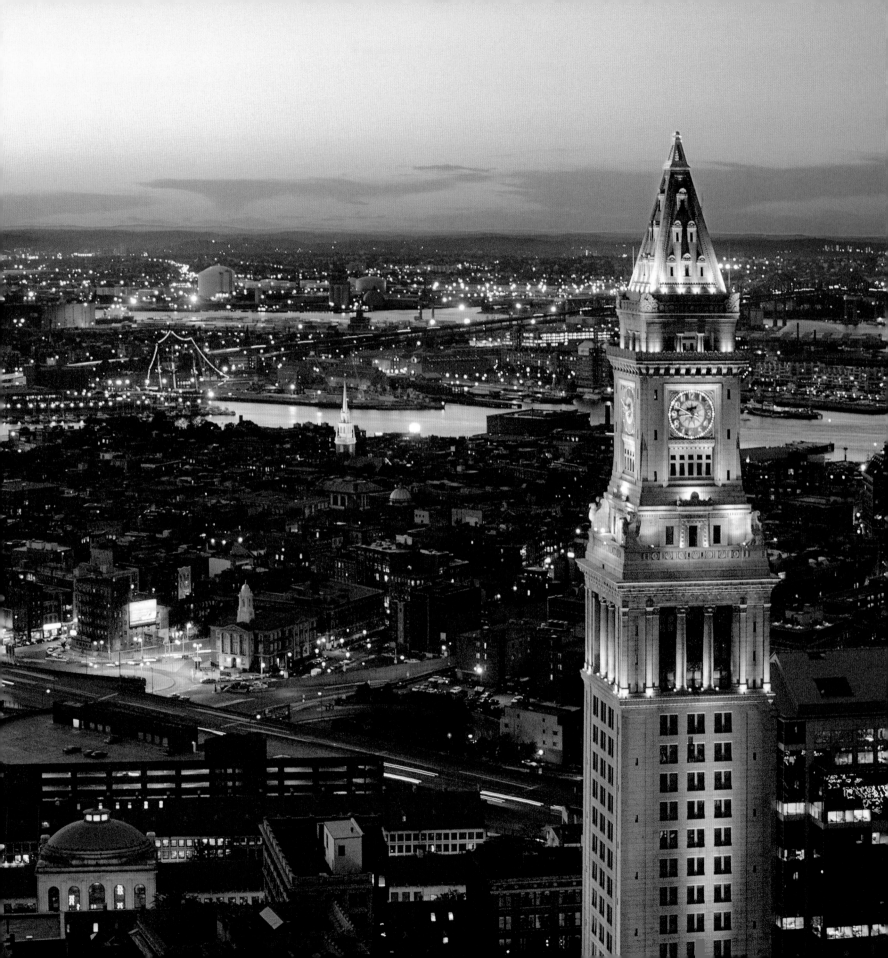

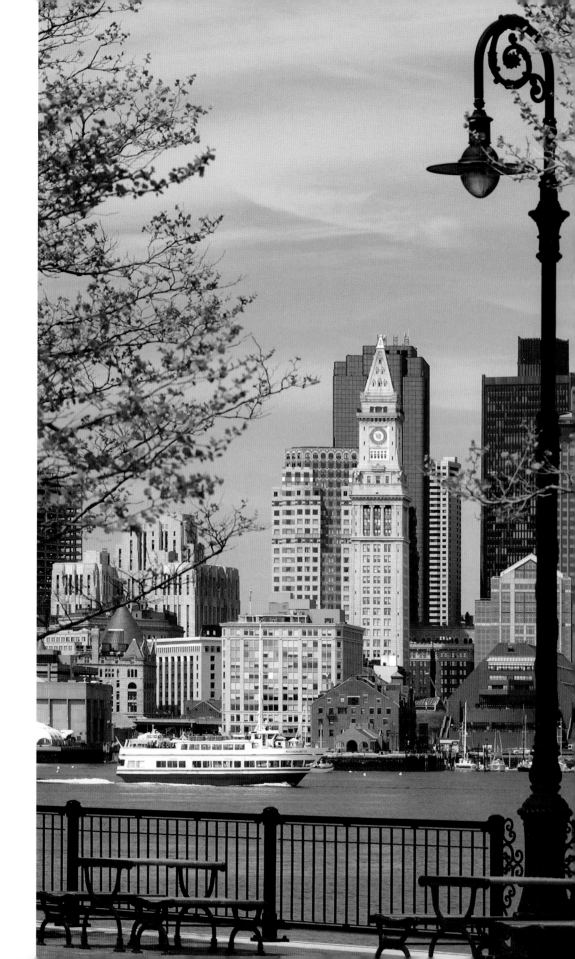

From across the Charles River, Boston's
Financial District, Custom House Tower
and harbor are clearly seen. Boat tours and
ferries are common sights, and Bostonians
and tourists alike enjoy the waterfront
paths and Esplanade.

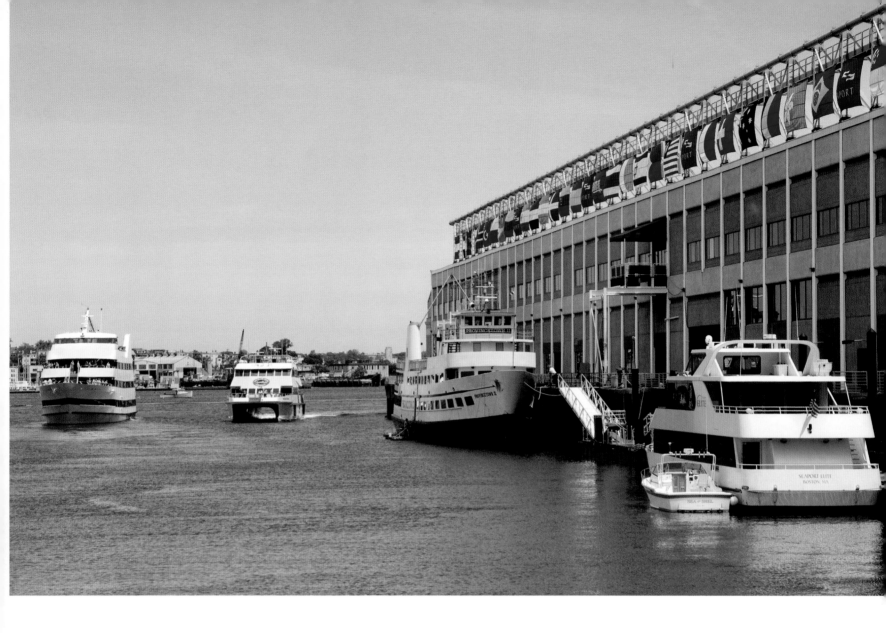

Many harbor tour boats are docked near the World Trade Center in Boston. These motorized craft offer a pleasant way to see the city's sights from the water.

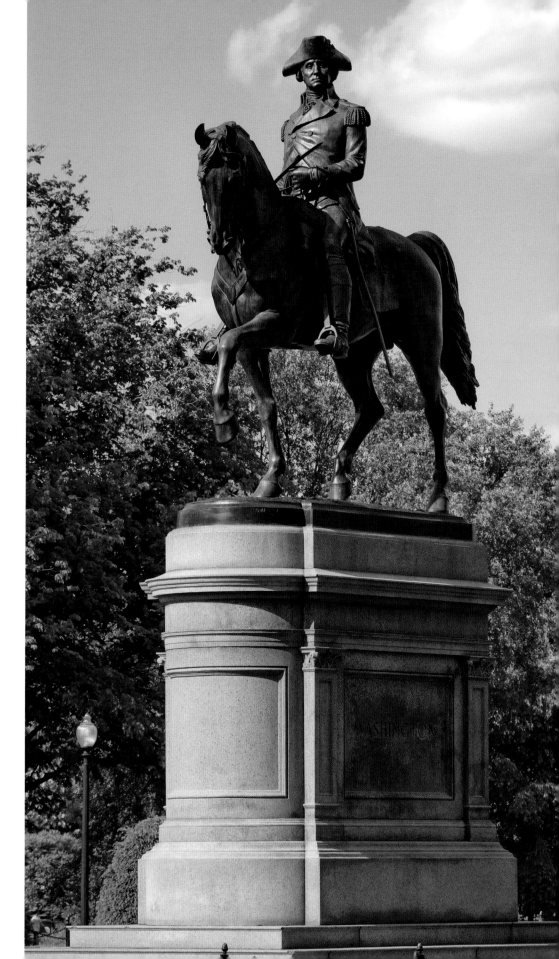

Cast in bronze by Thomas Ball and dedicated on July 3, 1869, this triumphant statue of George Washington on horseback is widely considered to be one of the finest in the city. It is located in the lush surroundings of the Boston Public Gardens.

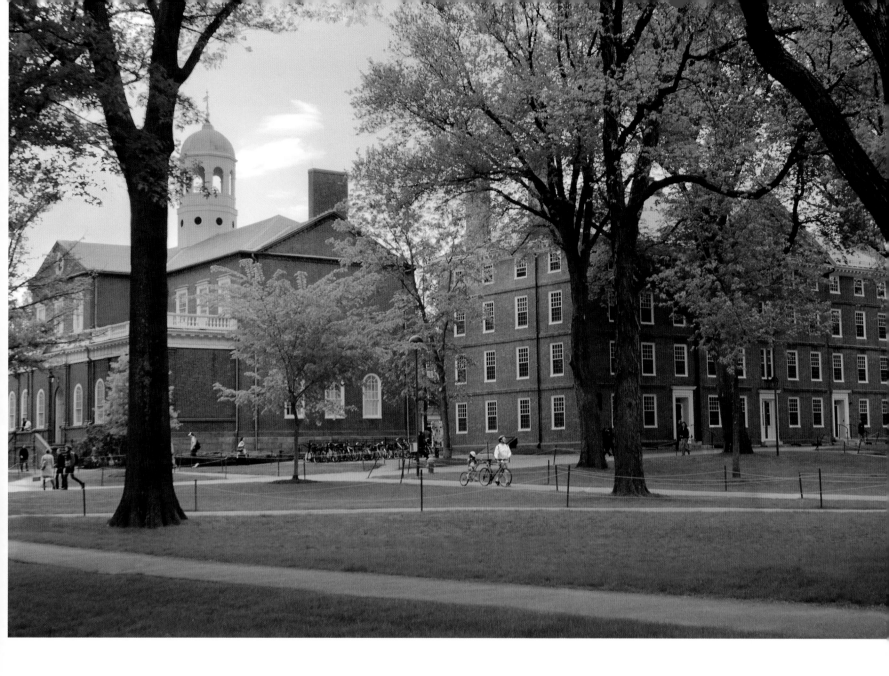

Harvard University is rich in history. Hollis Hall (right) was built in 1763 and used by George Washington's troops as barracks during the American Revolution. Its dormitories have housed some of the university's most famous alumni, including Ralph Waldo Emerson and Henry David Thoreau.

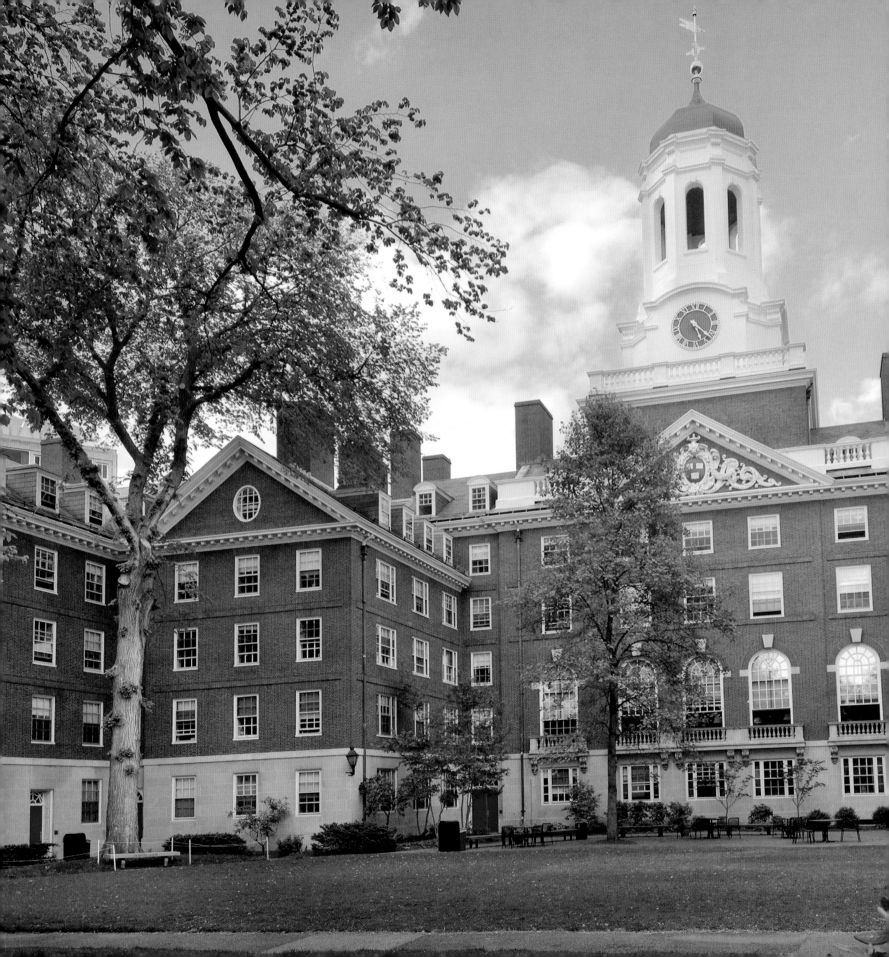

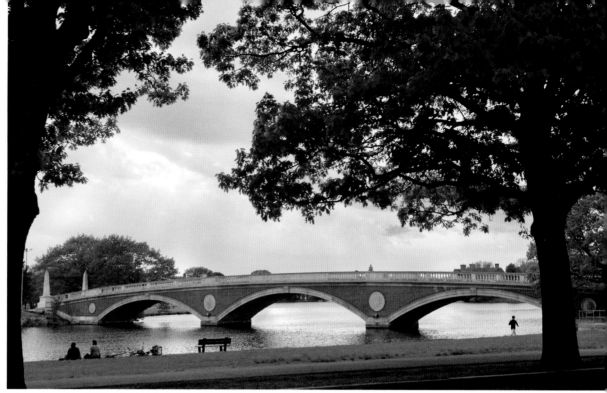

The John W. Weeks Bridge, a pedestrian bridge over the Charles River, was built in 1927. It connects Harvard University's traditional campus in Cambridge with the newer Allston campus. The Weeks Bridge is a popular spot from which to observe the famous Head of the Charles Regatta.

OPPOSITE PAGE: Puritan leaders established a college here in 1636; two years later, John Harvard, a cleric, died and bequeathed not only all his books but also half his estate to the young school, which was subsequently named after him. As well as being the oldest university in the country, Harvard is one of the most prestigious schools in the world.

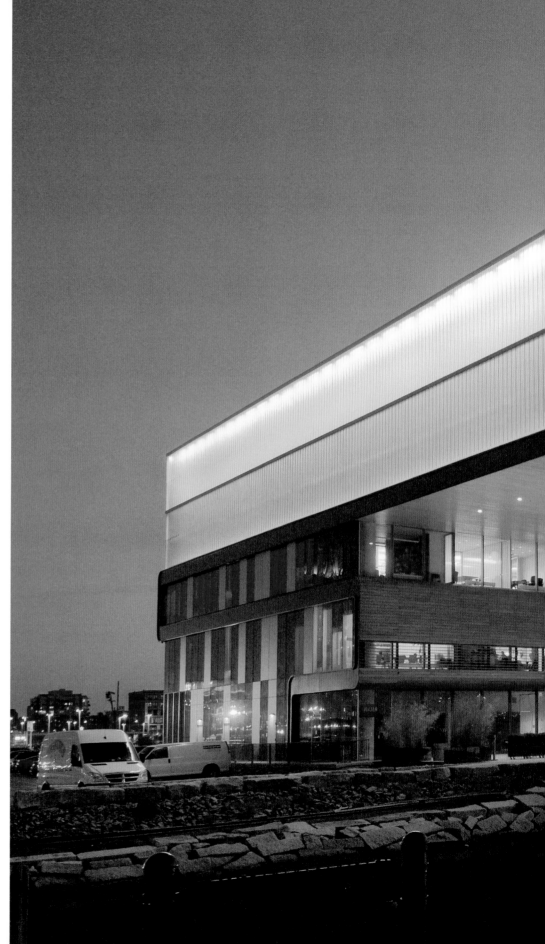

Boston's Institute of Contemporary Art moved to this stunning steel, glass and wood building on Fan Pier in 2006. Unveiled to critical acclaim, it is the first new art museum to open in the city in nearly one hundred years.

BELOW: The Sandra and Gerald Fineberg Art Wall, designed to enliven the lobby of the new Institute of Contemporary Art, features 52 mirrored glass windows in dazzling hues and varying sizes.

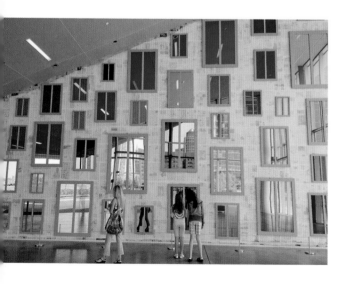

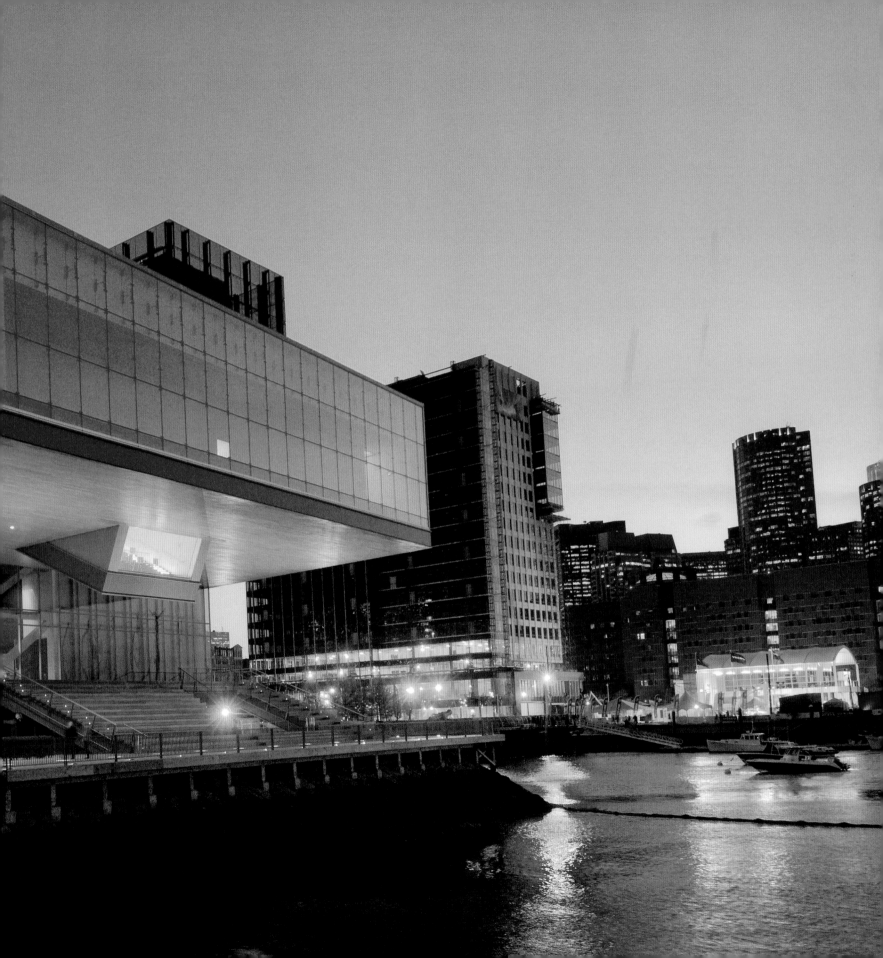

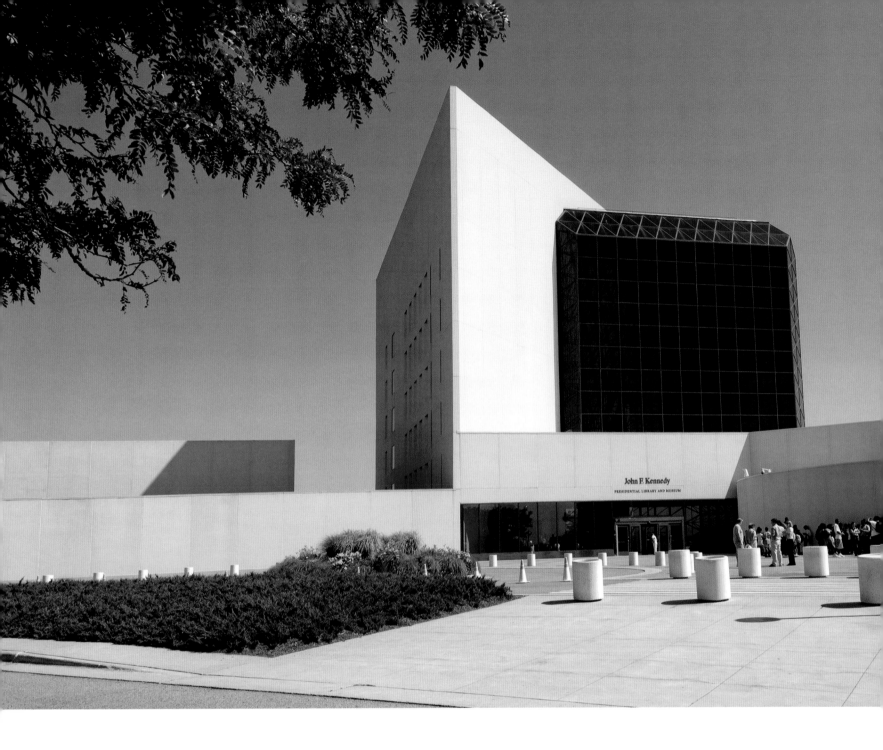

The John F. Kennedy Presidential Library and Museum is located on a 10-acre park on Columbia Point, overlooking the sea that JFK loved and the city that helped launch him into history. The soaring white concrete and glass structure was designed by I.M. Pei and officially dedicated in 1979.

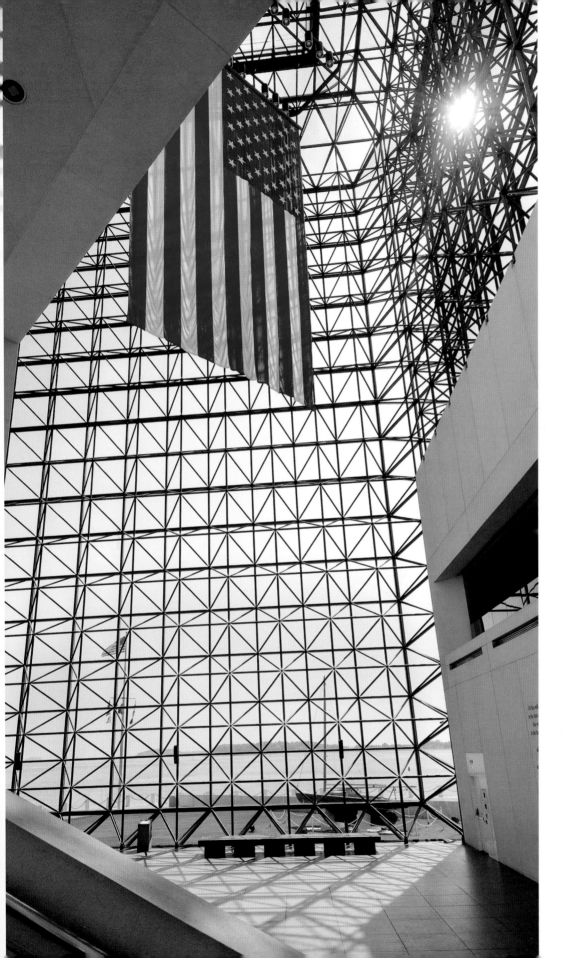

Inside the John F. Kennedy Presidential Library and Museum is this dramatic 50-foot wall of glass, which provides spectacular views. The center boasts numerous exhibits, including an extensive chronicle on the thousand days of Kennedy's presidency and great issues that faced the nation during that time, including the Cuban Missile Crisis and the Space Race.

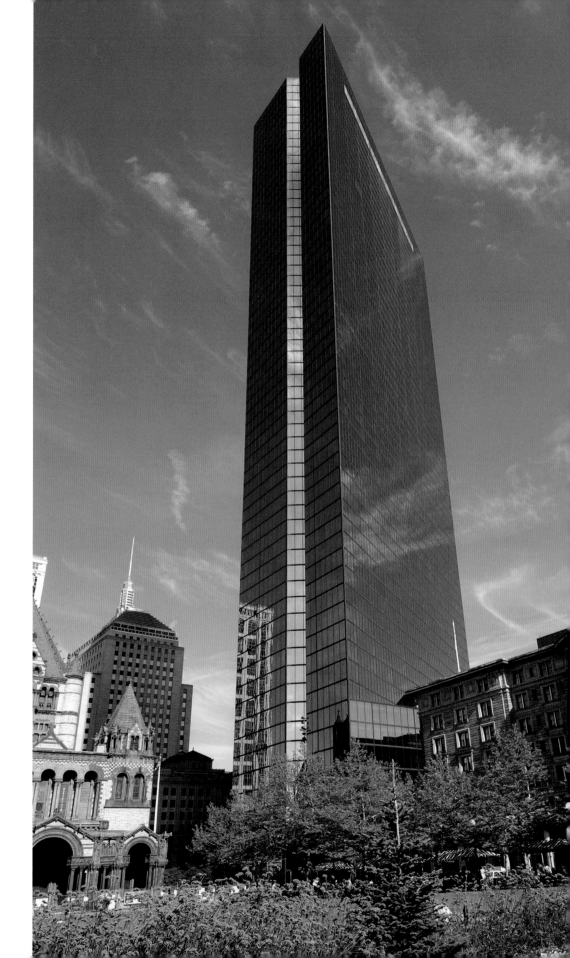

The 60-story, 790-foot John Hancock Tower is one of Boston's most recognizable landmarks. It was completed in 1976 and remains New England's highest skyscraper. A modernist parallelogram with deep vertical notches, it was designed by I.M. Pei and Henry N. Cobb. The granite and sandstone Trinity Church, routinely voted one of America's 10 finest buildings, can just be seen to the left.

Both the Berkeley Building (the Old John Hancock Tower) and the soaring John Hancock Tower are seen rising from Copley Square. Although the John Hancock Tower revealed several major flaws, including a weak foundation and a nausea-inducing sway, all have been fixed over time.

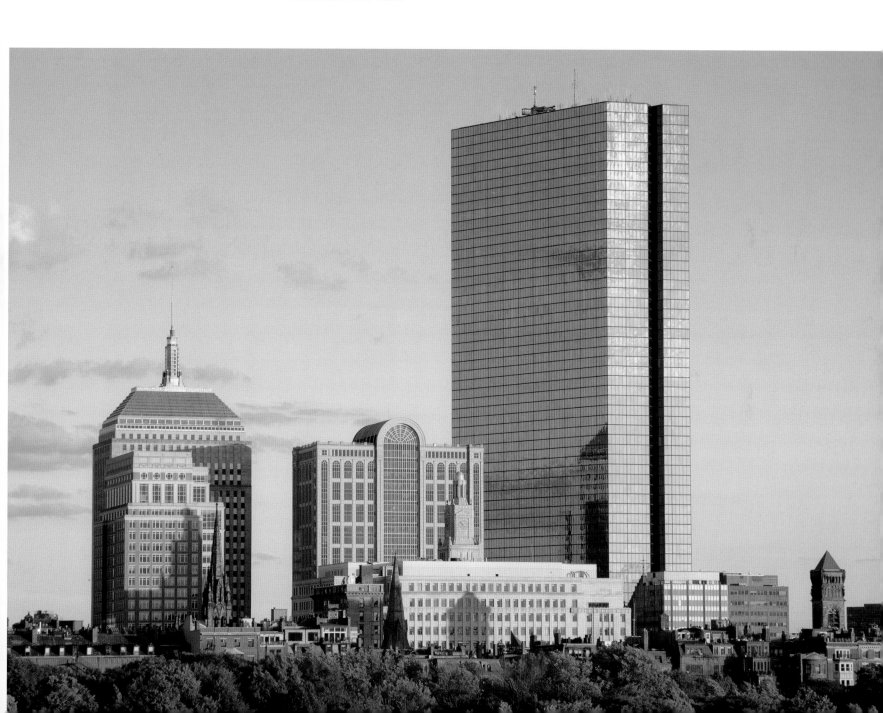

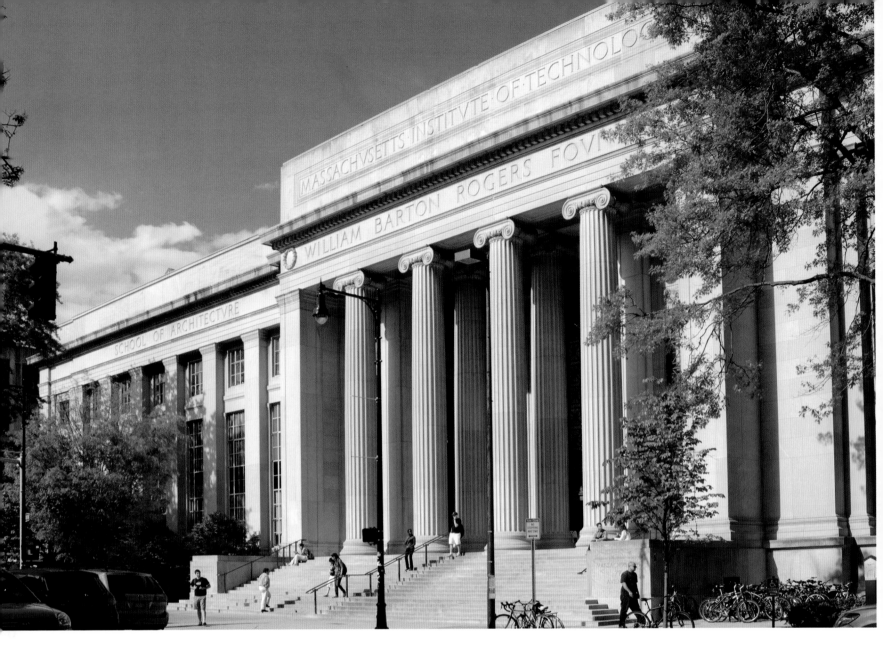

The Massachusetts Institute of Technology in Cambridge, founded in 1861, has evolved over the years to become one of the foremost places in the world to study science and engineering. Several architectural masterpieces dot the MIT campus.

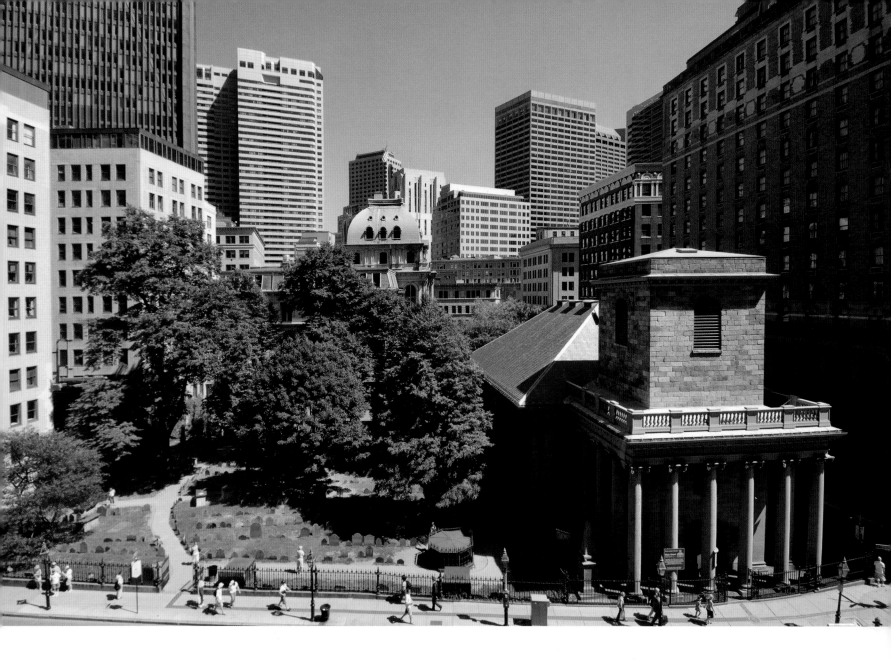

The original King's Chapel was a wooden structure built in 1688. When a larger building was needed in 1749, the present granite church was constructed around the shell of the old one, which was dismantled and thrown out the windows. Following the Revolution, the Anglican chapel became Unitarian.

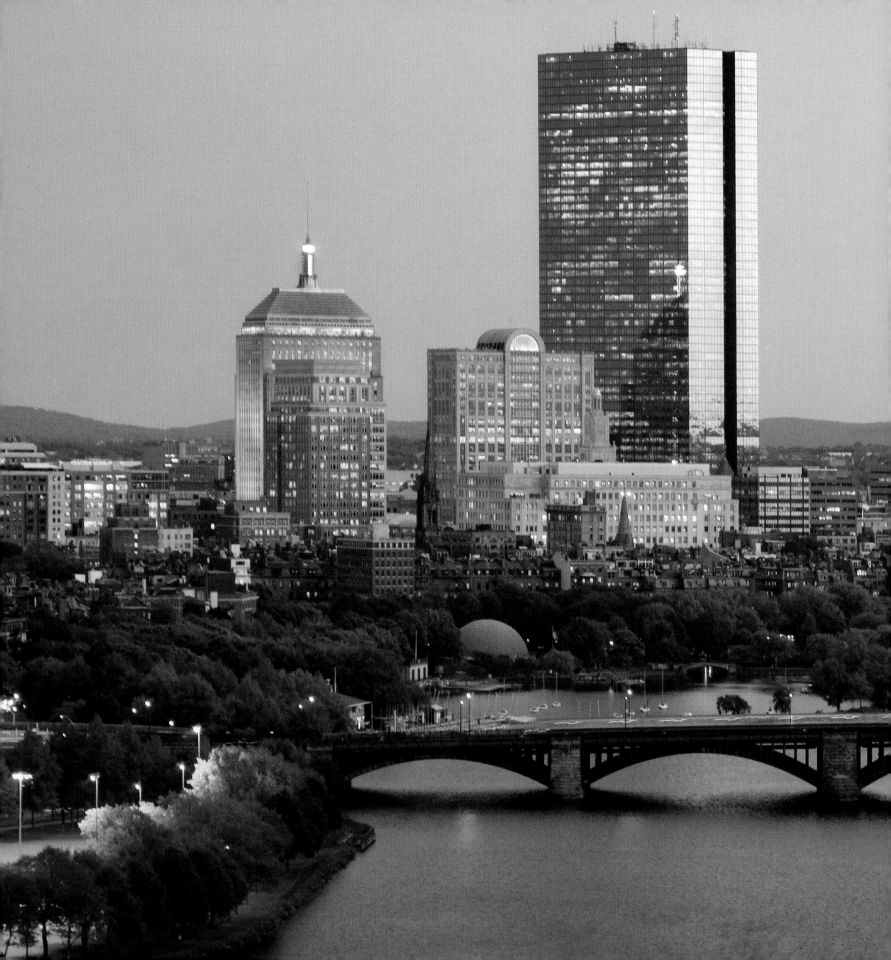

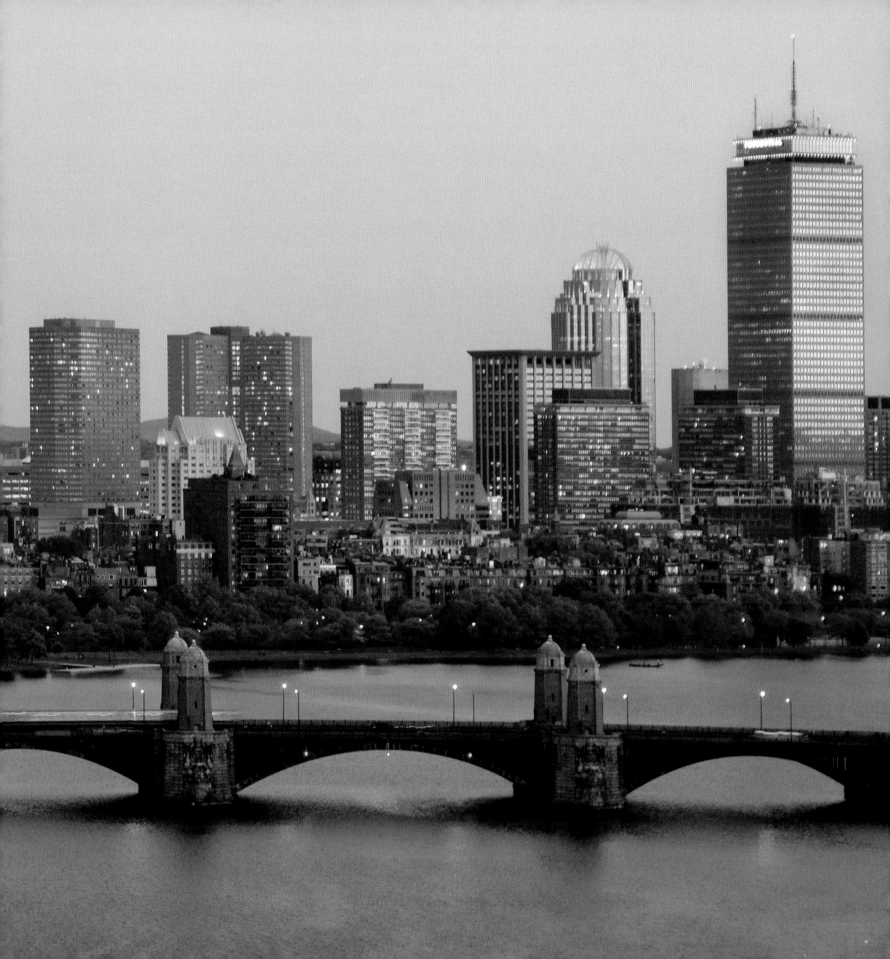

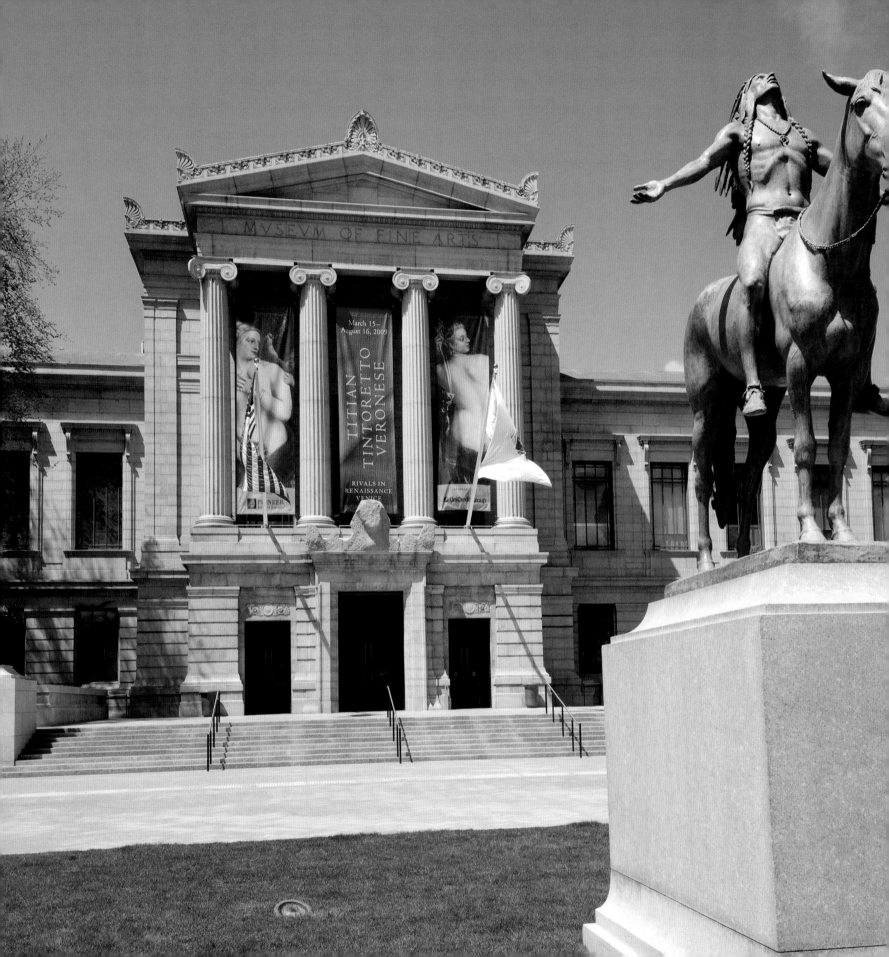

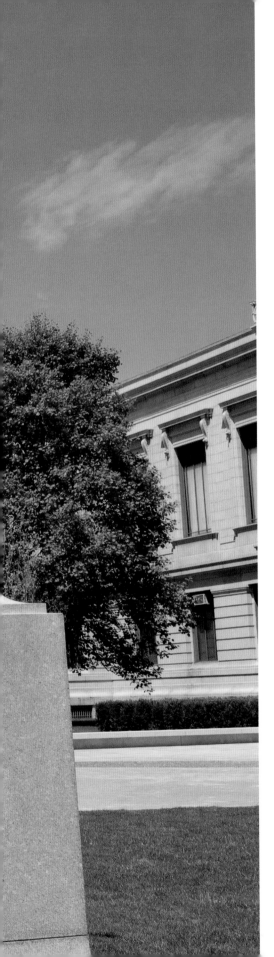

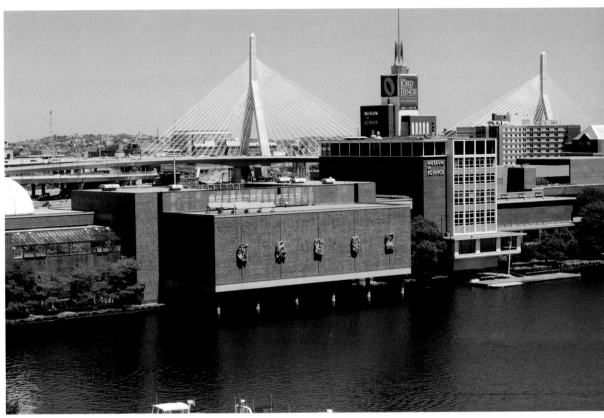

The Museum of Science and Science Park stand atop – and now virtually obscure – an inactive flood control dam at the mouth of the Charles River. Since the original structure was built in 1951, theaters, planetariums and other features have been constructed. The museum now boasts more than 550 interactive exhibits.

OPPOSITE PAGE: Boston's Museum of Fine Arts is among the largest fine arts museum in the United States, with nearly half a million treasures that range from Egyptian mummies to works by Monet, Rembrandt, van Gogh and Renoir.

PREVIOUS PAGE: The Longfellow Bridge over the Charles River is one of the most architecturally distinguished crossings in the city. Completed in 1908 and until 1927 known as the Cambridge Bridge – when it was renamed in honor of the poet and longtime resident Henry Wadsworth Longfellow – the structure is 2,135 feet long. Its distinctive granite towers have given it the nickname "the Salt and Pepper Bridge."

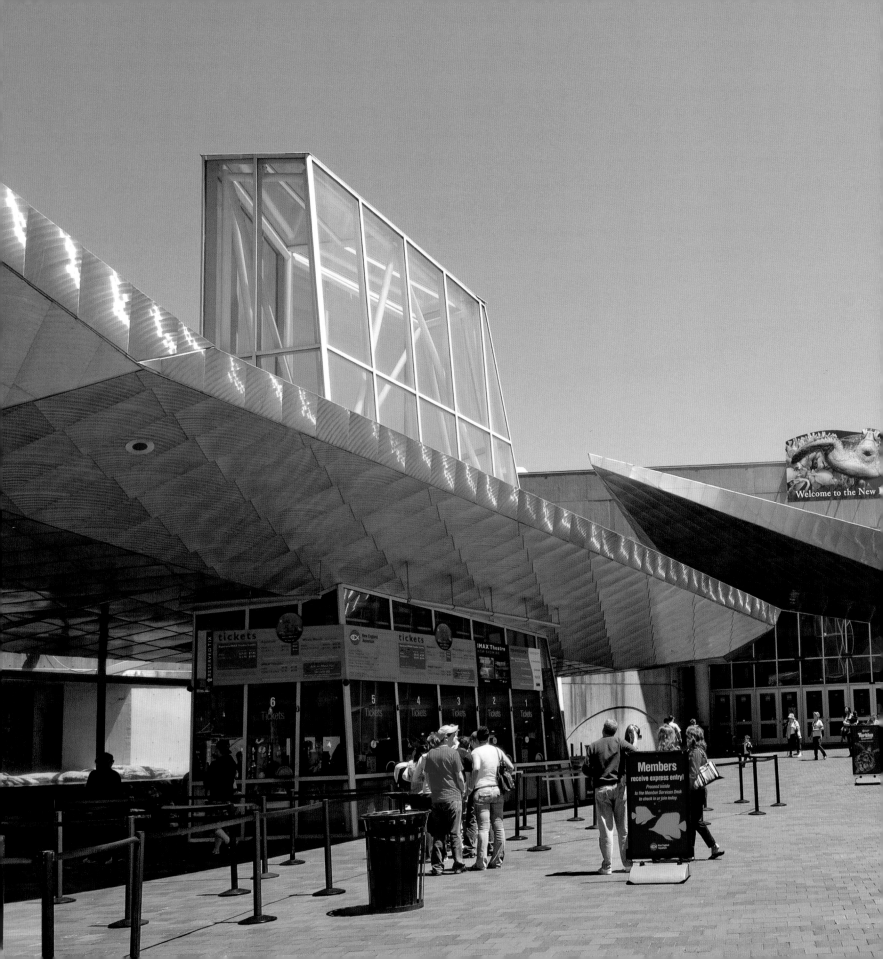

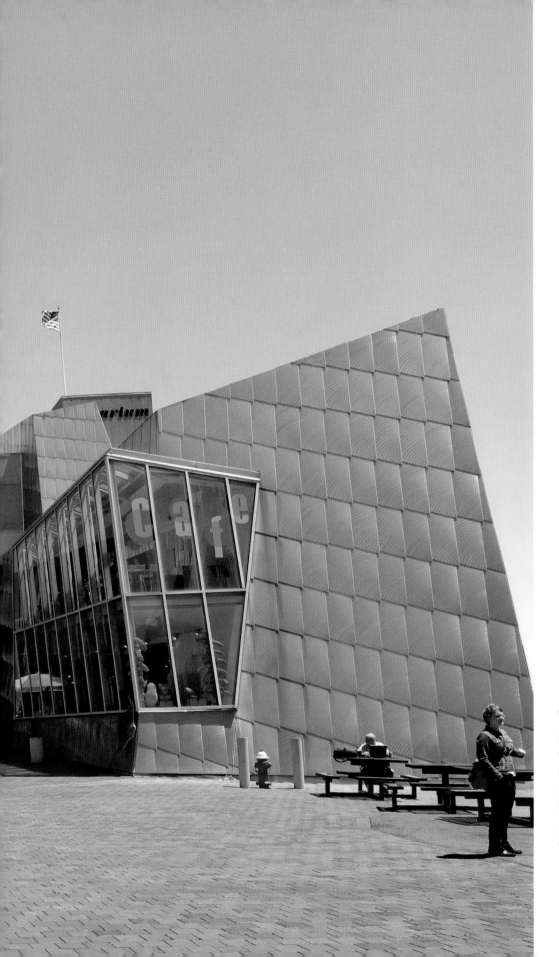

The New England Aquarium is the major attraction on Boston's Central Wharf. The core structure, with its main 200,000-gallon saltwater tank, was designed in 1969. A recently added wing includes an IMAX® theater. From sharks to sea turtles, and penguins to seals, there are marine animals to please any visitor.

Eight blocks along Newbury Street in the Back Bay area offer some of the city's finest (and most expensive) shopping. Whether seeking out classy boutiques, brand name stores or bargain finds, shoppers will always find something to suit their needs in these elegant buildings.

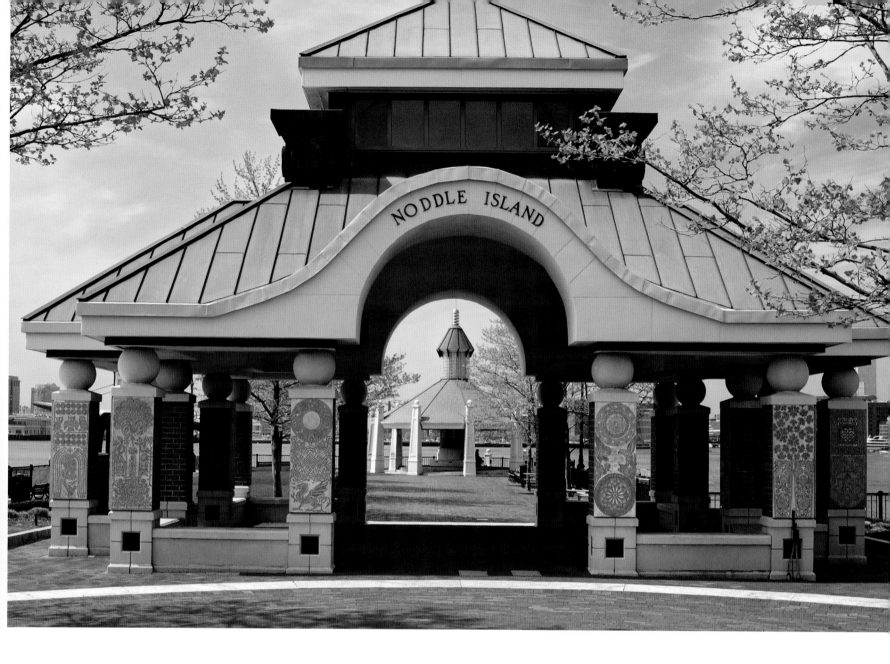

East Boston was known as Noddle's Island for more than two centuries, named in honor of William Noddle, who first settled in the area in 1629. Today the old name is remembered at the pavilion in Piers Park, one of Boston's newest waterfront recreation areas.

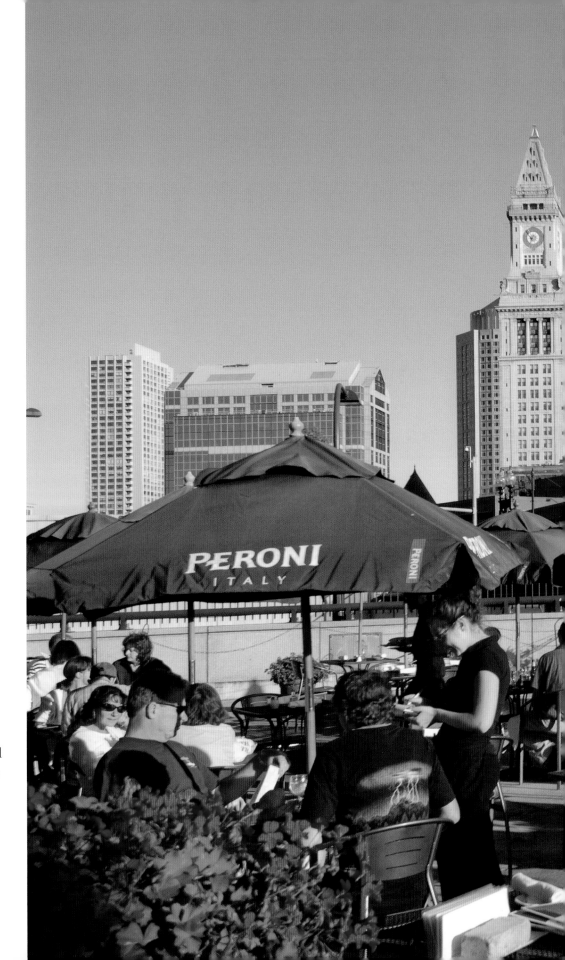

Boston's North End, although relatively small in area, is famous for its dense concentration of eating establishments. Although Boston is best known for its seafood, such as New England clam chowder, a vibrant restaurant scene offers an array of choices.

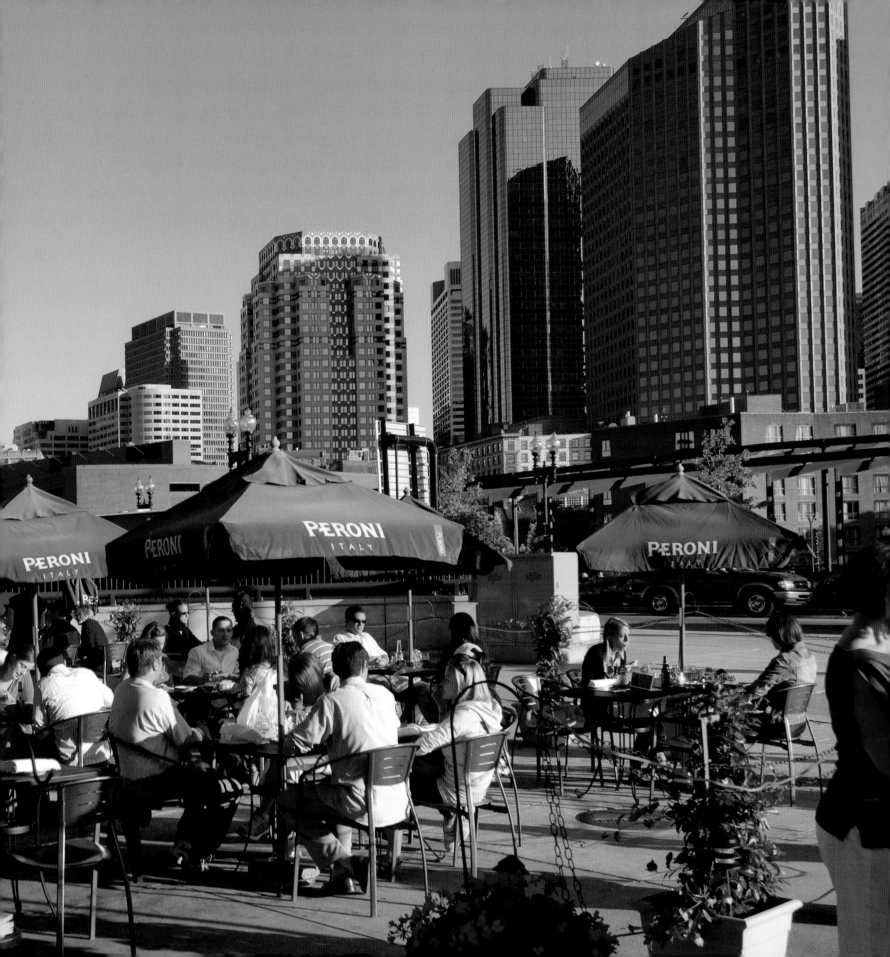

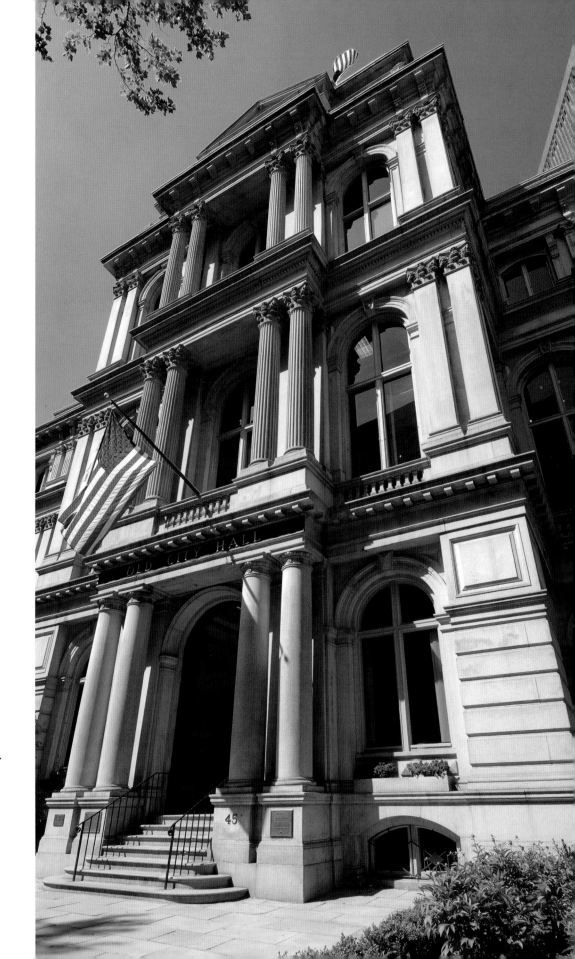

Boston's Old City Hall served that function for more than a century, from 1865 to 1969. Now occupied by offices and a restaurant, this grand structure is one of the earliest examples of adaptive use in Boston. In the 1960s, the trend was to tear down old buildings rather than reinventing them.

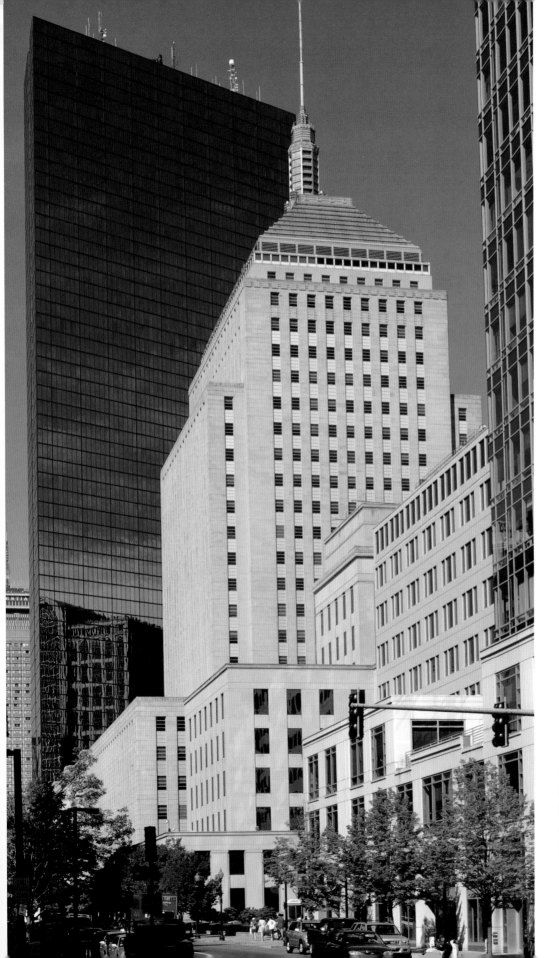

The Berkeley Building, also known as the Old John Hancock Tower, is a handsome 36-story structure, only one foot shorter than the Custom House Tower. It was completed in 1947, the second of three John Hancock buildings in the city.

Built in 1712, the Old Corner Bookstore at the corner of Washington and School Streets is one of the earliest surviving structures in the city. For many years, the building was the home of a bookstore and printing shop, producing editions of such notable New England authors as Longfellow, Emerson, Thoreau, Hawthorne and Alcott. No longer a bookshop, the building still remains a draw for book lovers.

OPPOSITE PAGE: Named after the granary that stood here in colonial days, the Old Granary Burying Ground opened in 1660. Hardly any stones mark actual burial spots – the orderly arrangement is a result of recent grounds-keeping efforts. The Old Granary Burying Ground is the final resting place of many Revolutionary heroes, including Paul Revere and three signers of the Declaration of Independence: John Hancock, Samuel Adams and Robert Treat Paine.

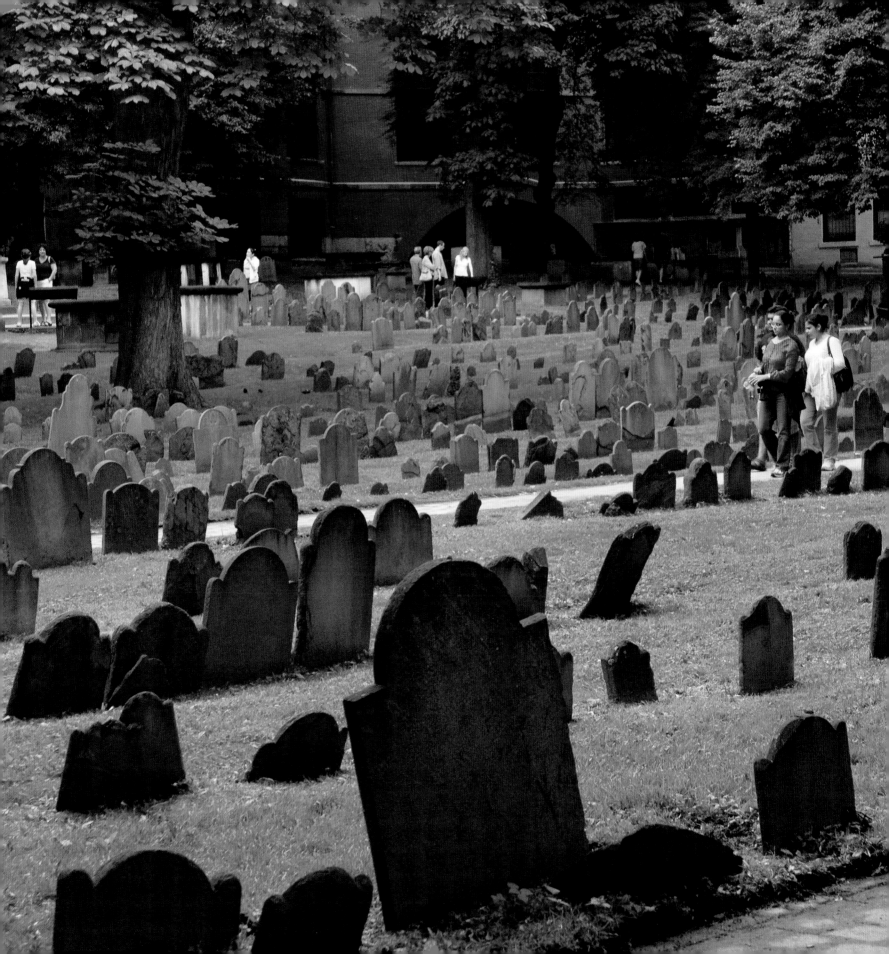

The Old South Meeting House, distinguished by its octagonal steeple, was built for Puritan services in 1729. From here, Samuel Adams gave the signal that led to the Boston Tea Party; in retaliation, the British turned the church into an officers' tavern and stable. In 1877, the building was preserved from destruction and restored.

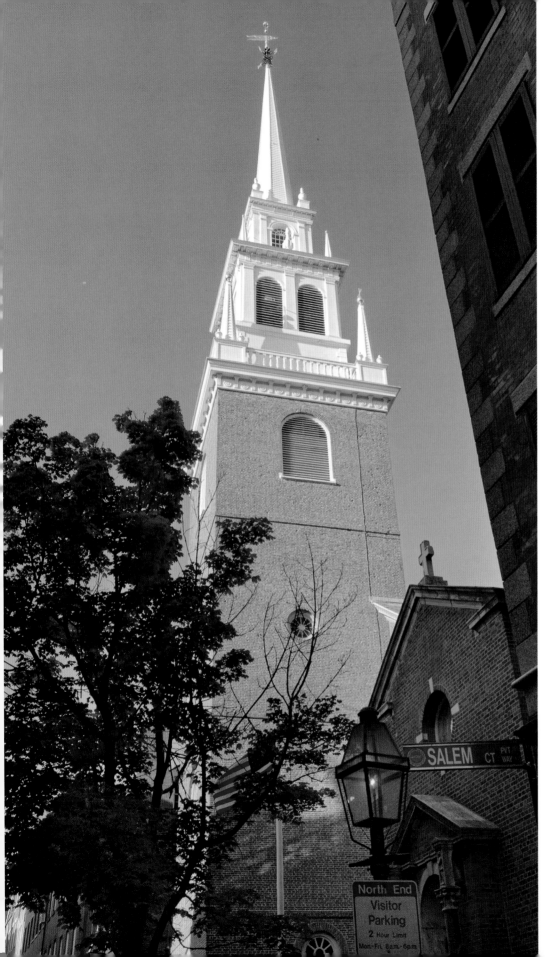

The Old North Church, officially known as Christ Church in the City of Boston, is a Georgian-style building on Salem Street dating to 1723. It was from the belfry of this steeple that Robert Newman aided Paul Revere by hanging a pair of lanterns to warn Charlestown patriots of the westward departure of British troops.

Dramatic fife-and-drum performances are seen and heard at the Old State House on the Fourth of July and other special occasions. This music of the American Revolution reminds visitors of the building's historic significance. Within these walls, Samuel Adams, James Otis, John Hancock and John Adams debated the colony's future. From the balcony, the Declaration of Independence was read to Bostonians in 1776.

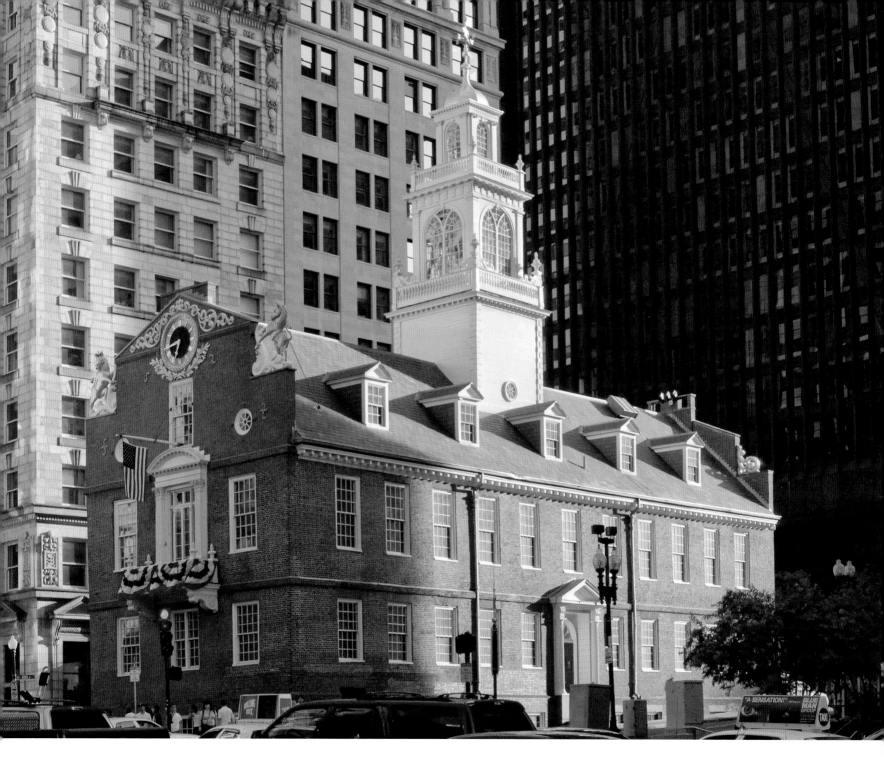

Now dwarfed by skyscrapers, the Old State House was the seat of the British colonial government for more than 60 years during the 18th century. A royal lion and unicorn are seen on the building's facade. Over the years the building has had many uses, including as Boston City Hall, a Masonic lodge and a produce market.

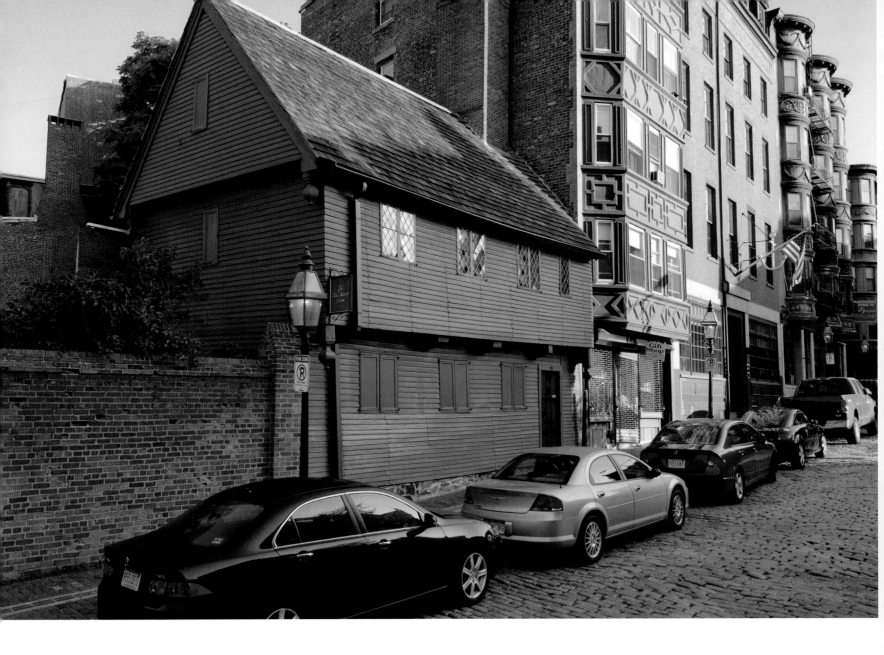

Paul Revere owned this small clapboard frame house, the oldest surviving example in the city, from 1770 to 1800. It was from here that the Revolutionary hero began his famous "midnight ride." Purchased in 1902 by the patriot's great grandson, the house was saved from demolition and opened its doors to the public only six years later.

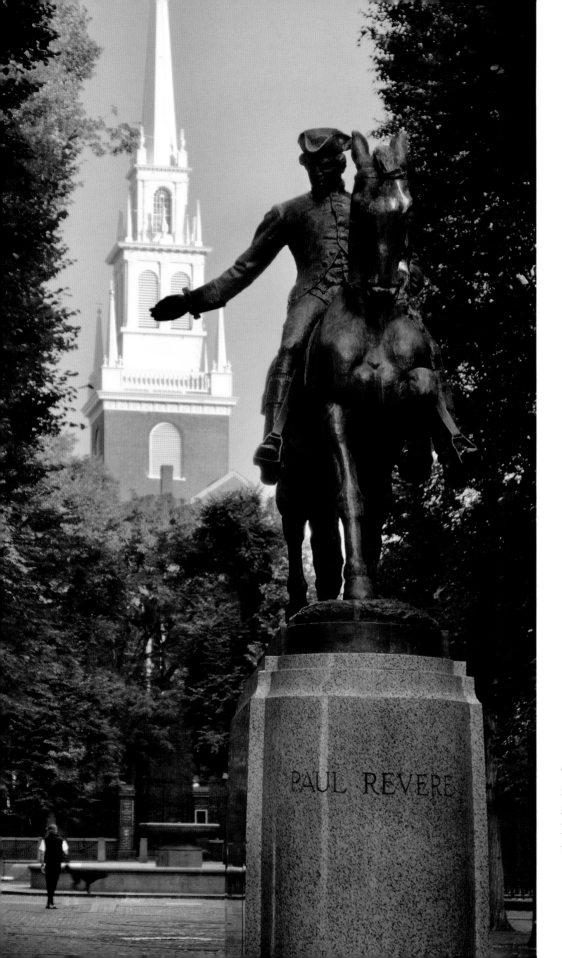

The statue of Paul Revere in James Rego Square was begun in 1883 but only sculpted and placed here in 1940. Twin rows of linden trees line the brick-paved plaza in the crowded North End neighborhood.

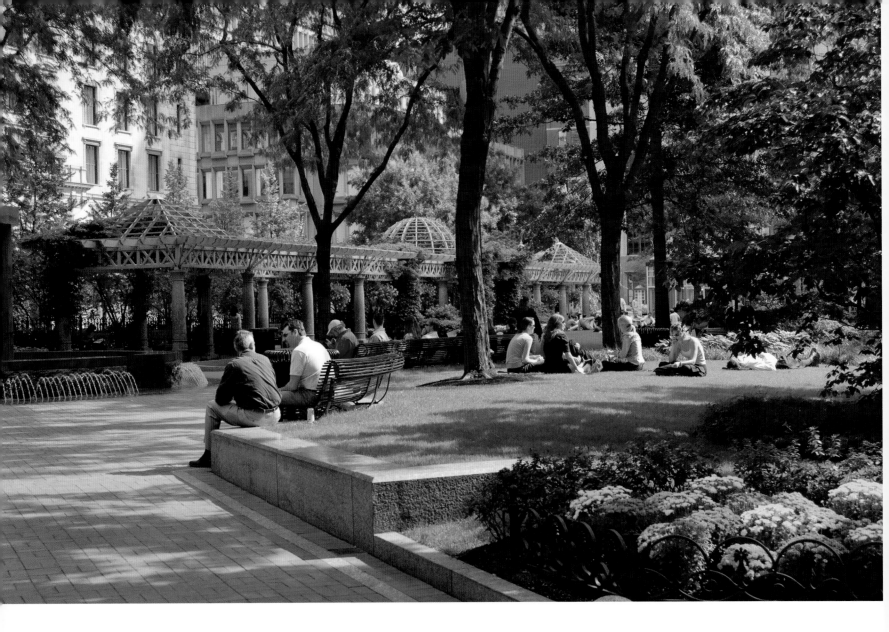

Post Office Square is an oasis of landscaped greenery in the midst of the soaring towers of Boston's Financial District. Unlike most of the city's parks, this one is privately owned. Post Office Square is a popular lunchtime destination for local workers.

OPPOSITE PAGE: Park Street Church, rising among the skyscrapers, has been one of the city's most influential pulpits since its founding in 1809. The building's design was adopted from one by the famous English architect Sir Christopher Wren and features a 217-foot white-painted steeple. The U.S. militia stored gunpowder in the basement of Park Street Church during the War of 1812.

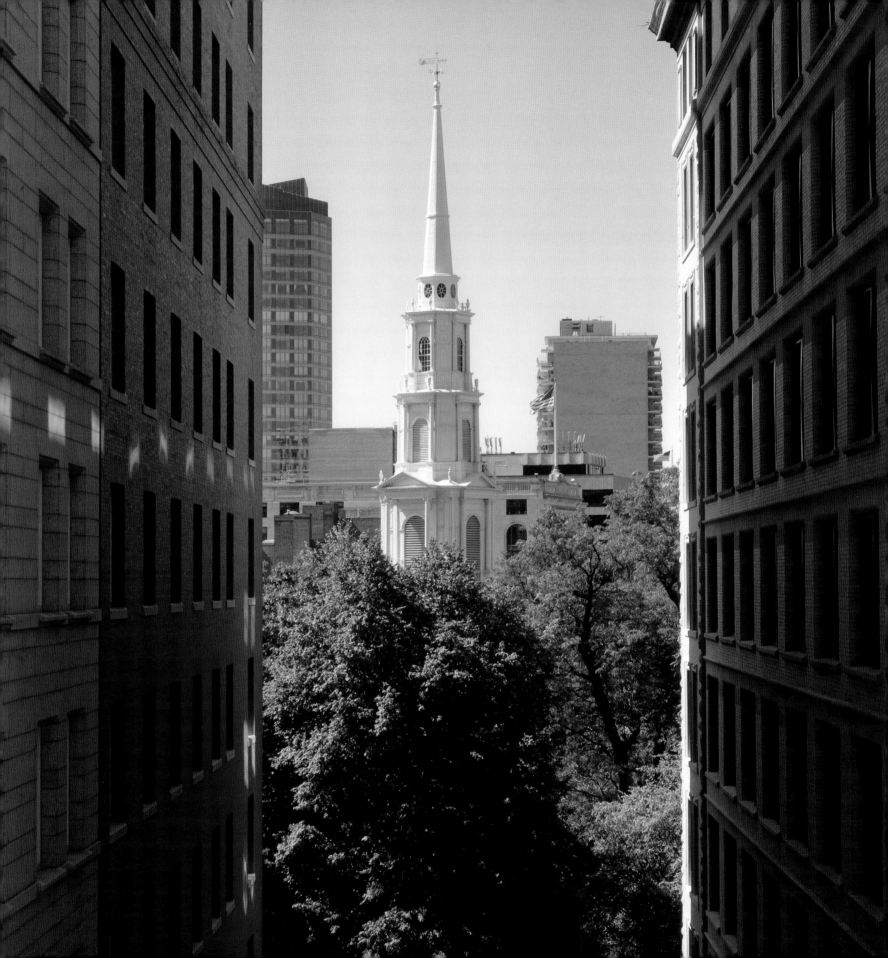

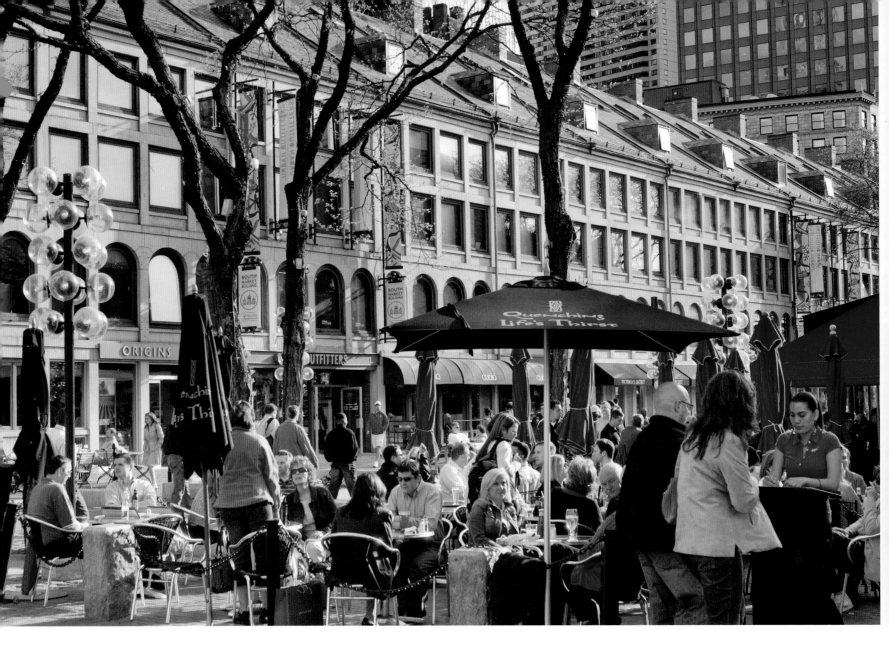

Quincy Market remains an immensely popular shopping and dining complex, attracting more than 18 million visitors annually. Once primarily occupied by grocers, this area is now better known for its fast-food stalls and restaurants.

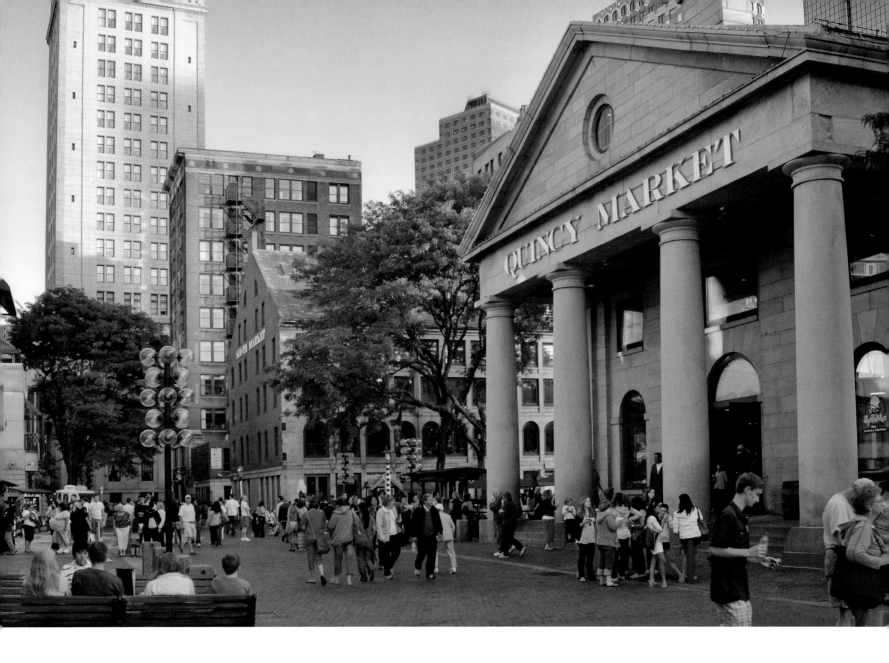

The Greek Revival structures of Quincy Market were built in the 1820s to better accommodate the bustling trade at Faneuil Hall. The market was later named for Boston mayor Josiah Quincy. By the mid-20th century the buildings had fallen into disrepair and were slated for demolition, but a group of dedicated citizens in the 1970s successfully petitioned to save and revitalize them.

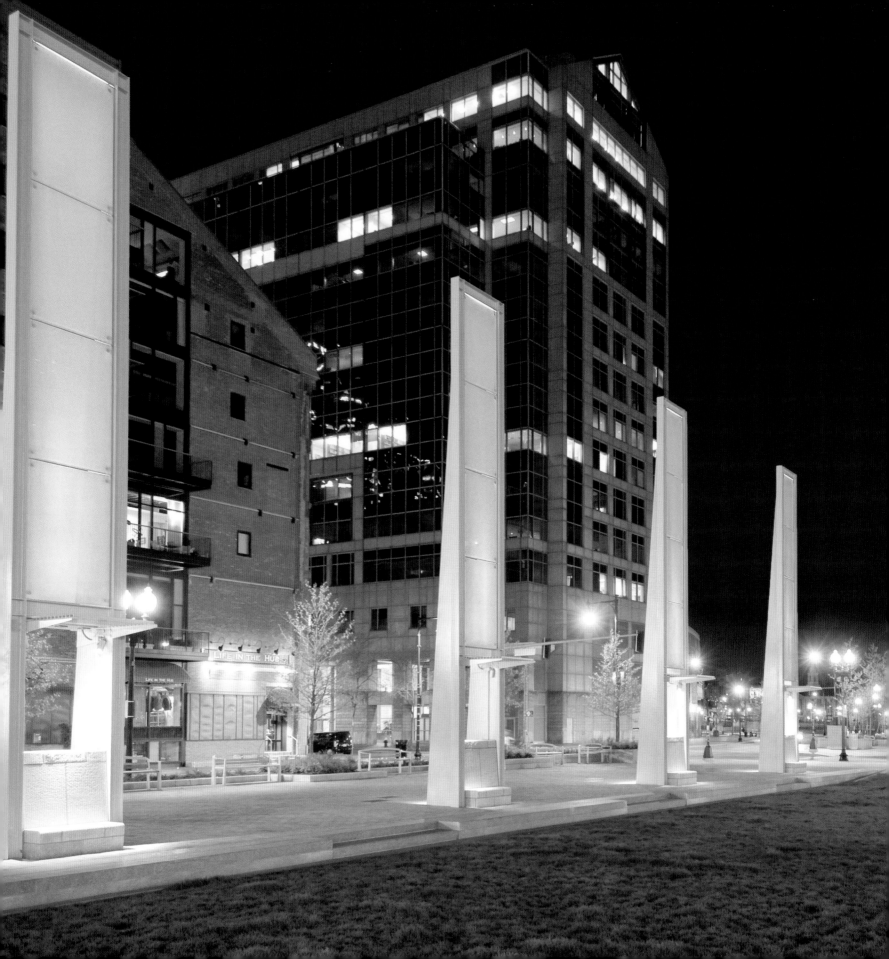

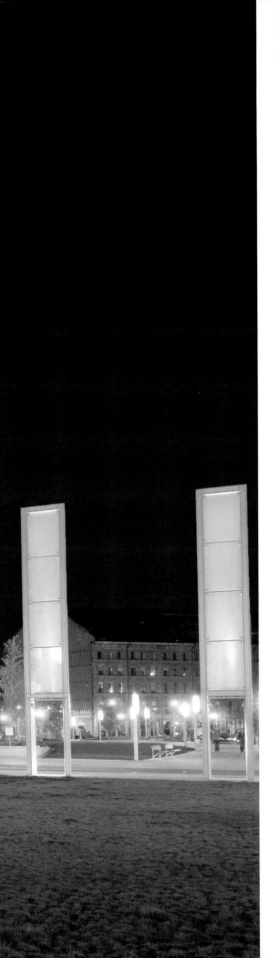

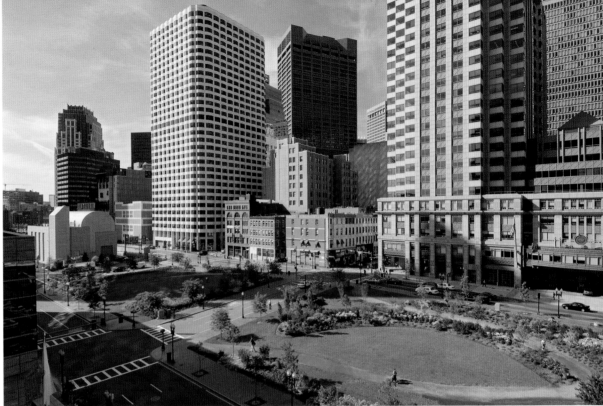

ABOVE & OPPOSITE: Rich in prime urban land when the Big Dig buried the stretch of Interstate 93 through the heart of Boston, the city established gardens, plazas and tree-lined promenades in many neighborhoods. The Rose Fitzgerald Kennedy Greenway is a series of four parks that snake along the old highway route, providing a welcome source of enjoyment for Bostonians where once they were mired in traffic.

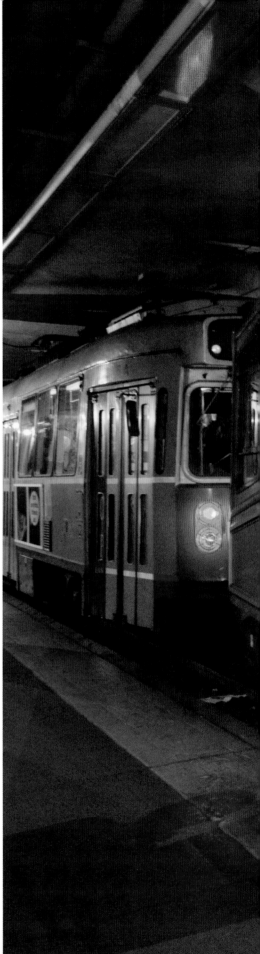

Tremont Street is one of Boston's busiest thoroughfares and the site of many of its famous landmarks. Numerous street vendors are found in this bustling stretch of town. The t-shirts celebrating *Cheers* honor the beloved television series that was set in the city.

OPPOSITE PAGE: Opened in 1897, the Green Line is a light rail / streetcar system. It is the oldest line of Boston's subway, running underground downtown before surfacing in the outlying areas.

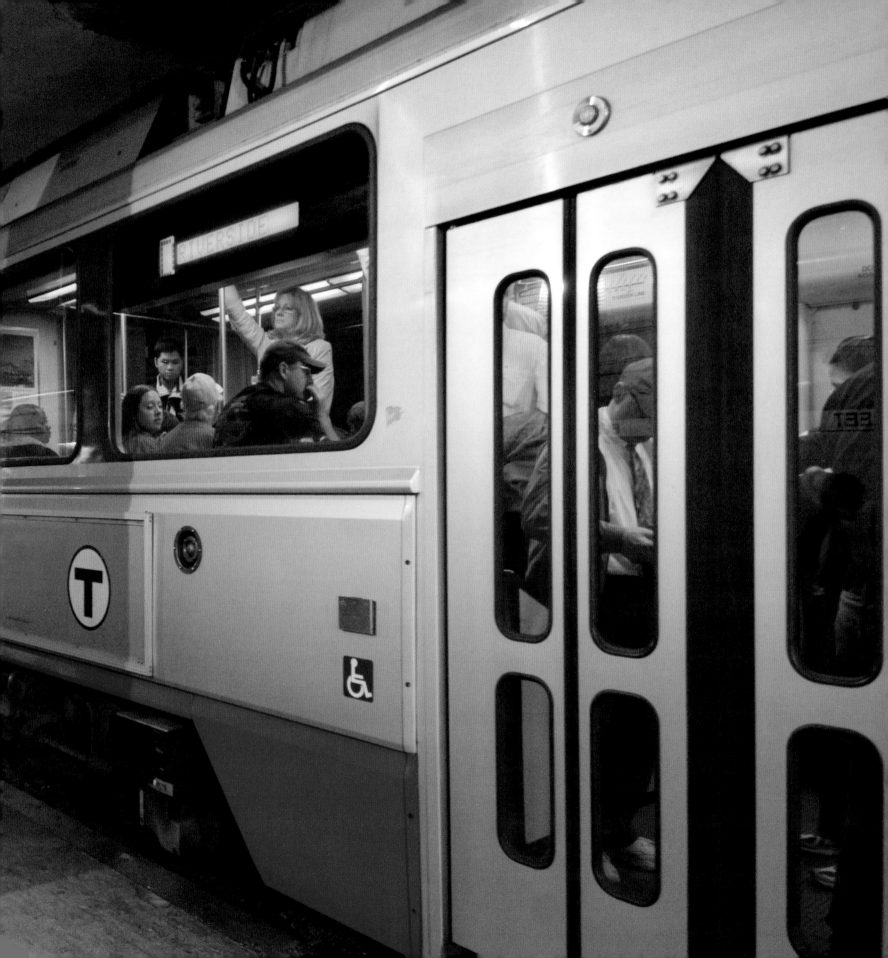

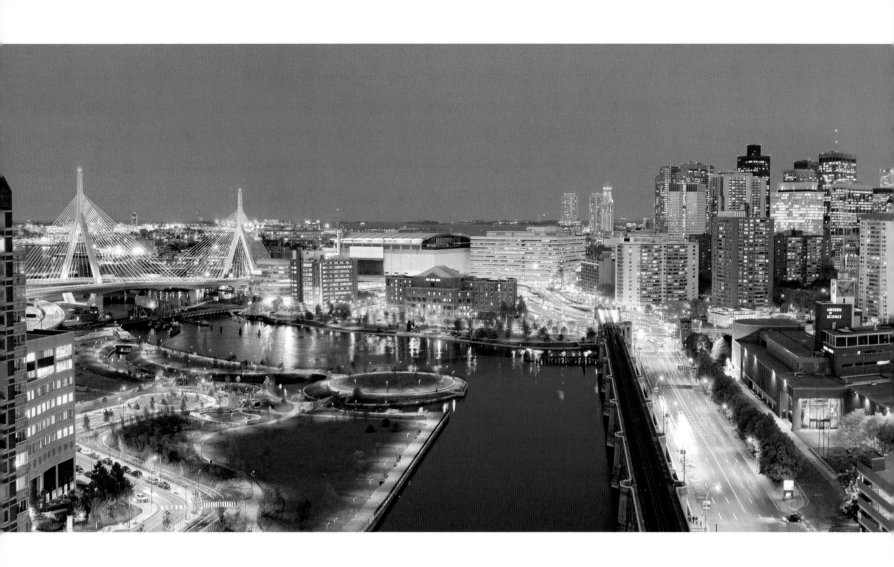

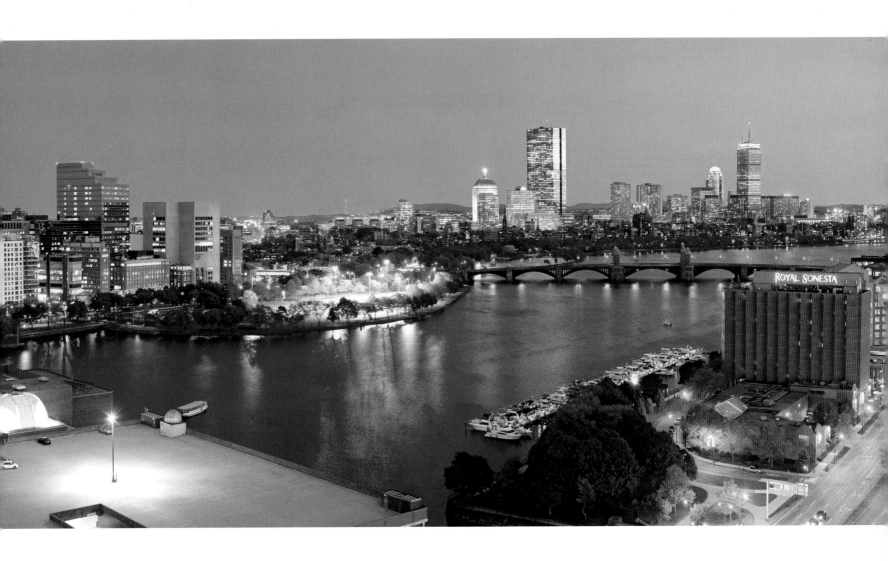

In this stunning evening panorama, the Museum of Science stretches away from us in the foreground over the old dam, and all of Boston stands proudly on the other side of the Charles River. To the far left is the Zakim Bridge. The towers of the Financial District rise in the middle, and to the far right are the John Hancock Tower and Back Bay.

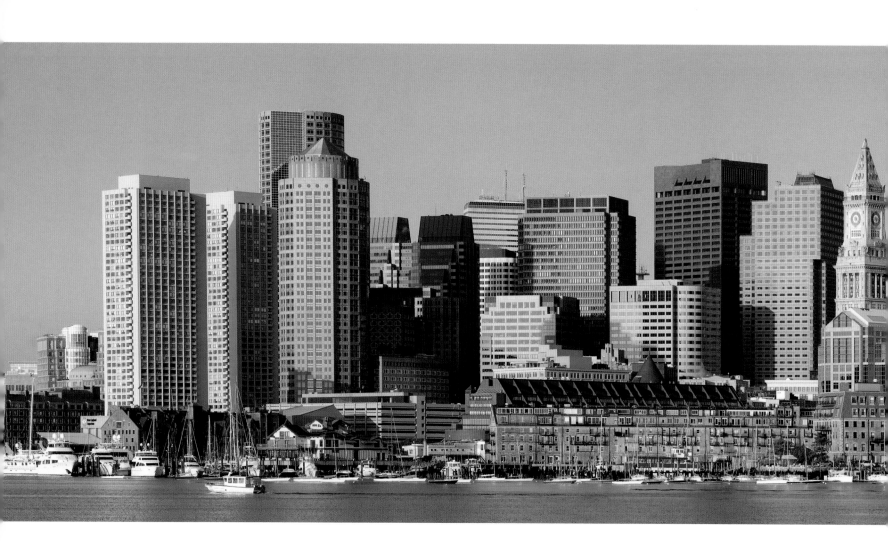

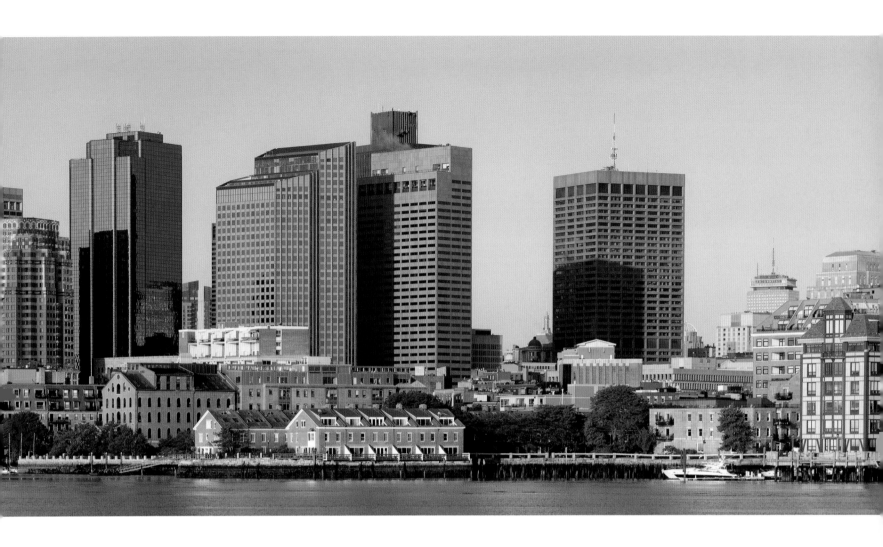

The towers of the Financial District, both old and new, can be seen on a beautifully clear day in this panoramic scene of the city from East Boston. Numerous sailboats appear in Boston Harbor, which stretches out past the Custom House Tower.

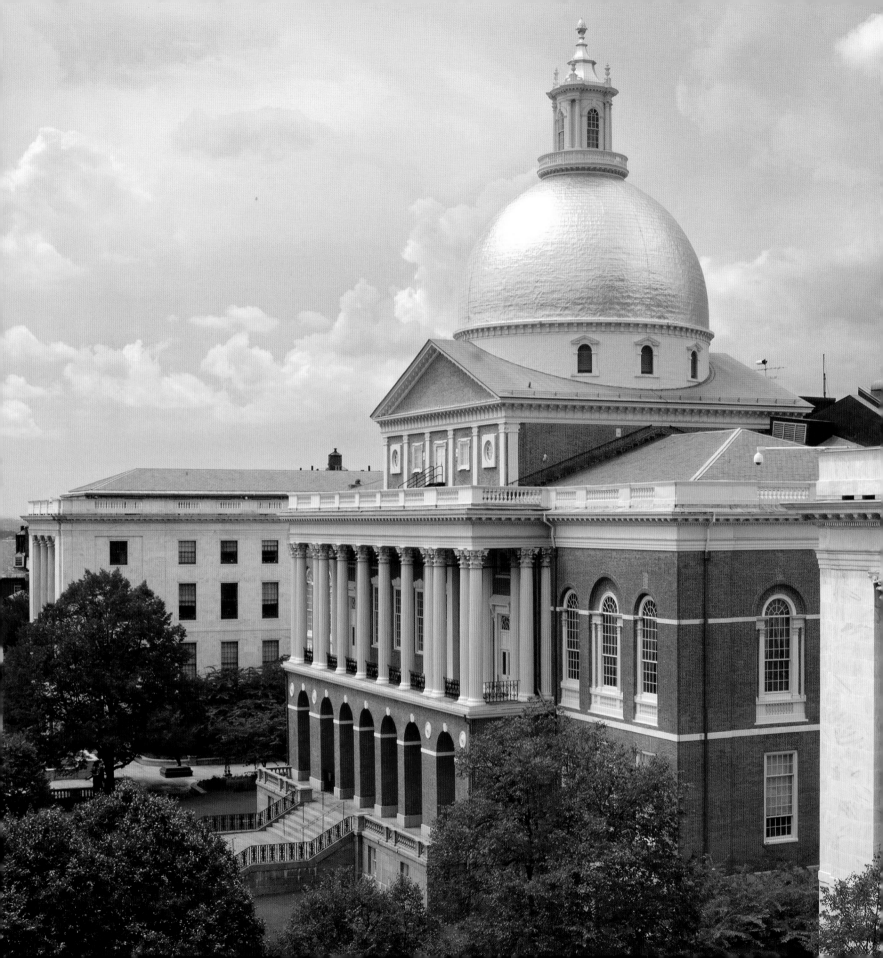

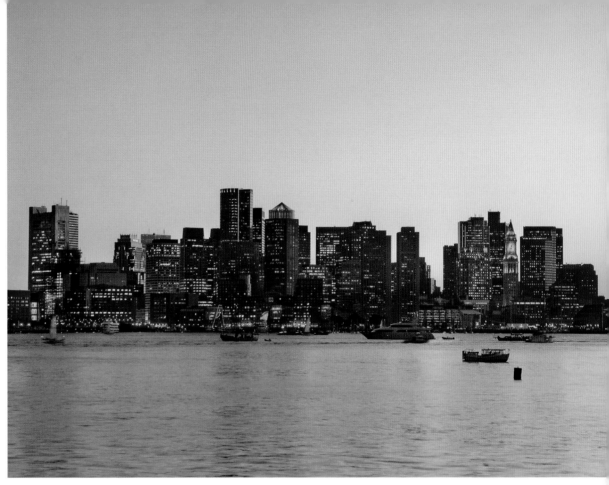

The towers of downtown stand out against the evening sky. Boston is home to numerous boating clubs and organizations. Sailing craft, cruise boats and large commercial tankers can be seen in Boston Harbor day and night.

OPPOSITE PAGE: Massachusetts State House is perched proudly upon Beacon Hill. Begun in 1795 by Samuel Adams and Paul Revere, it was completed only three years later. The building served as a model for the U.S. Capitol Building in Washington and countless other public structures around the nation. Its famous dome, sheathed in copper and brilliant gold leaf, is one of Boston's most cherished landmarks.

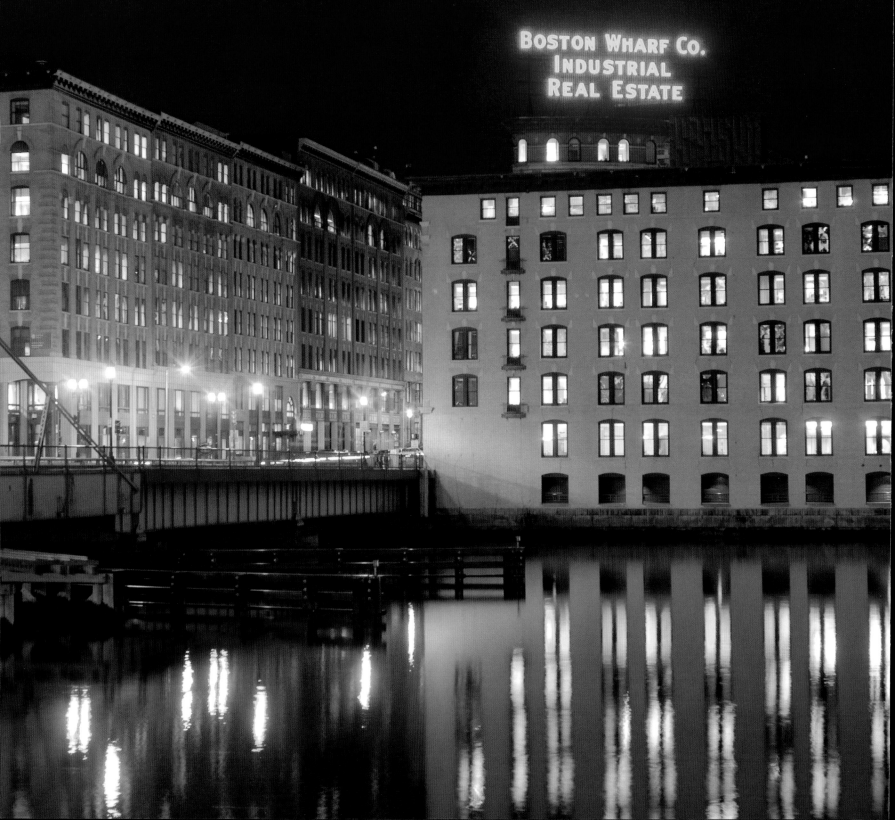

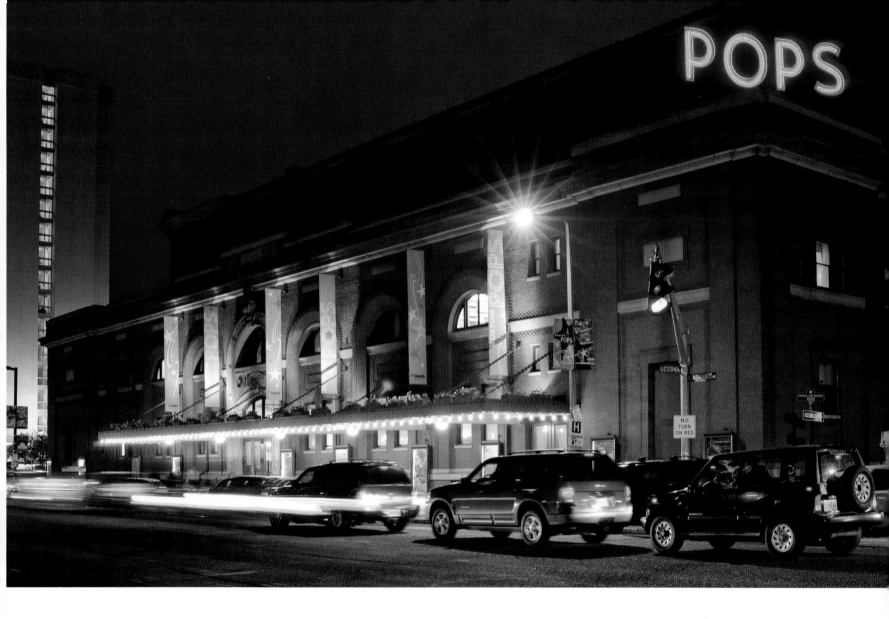

Symphony Hall opened on October 15, 1900, replacing the Old Boston Music Hall as the home of the Boston Symphony Orchestra. Widely regarded as one of the finest concert halls in the world, Symphony Hall also boasts one of the best concert hall organs, installed in 1949.

OPPOSITE PAGE: The Boston Wharf Company on Summer Street, established in 1836, describes itself as "dedicated to preserving, restoring & enhancing the landmark architecture of the historic Boston Wharf district while creating unique live, work and retail environments from the street up."

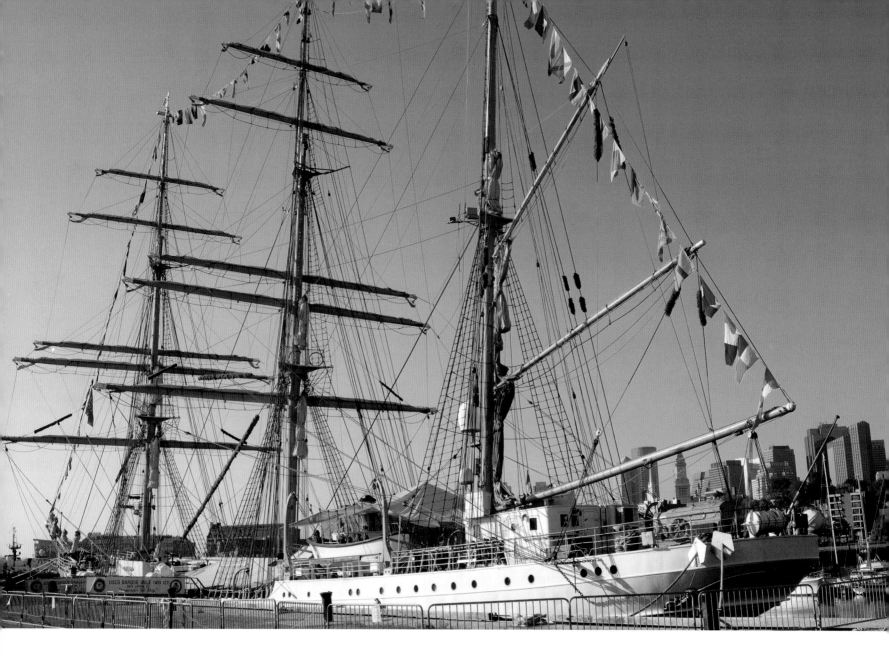

Daily cruises are available in classic sailing craft from Boston Harbor most days during the summer. When a tall ship festival makes Boston its port, it's an opportunity not to be missed. Ships come from all over the world, and many open their decks to Bostonians and tourists.

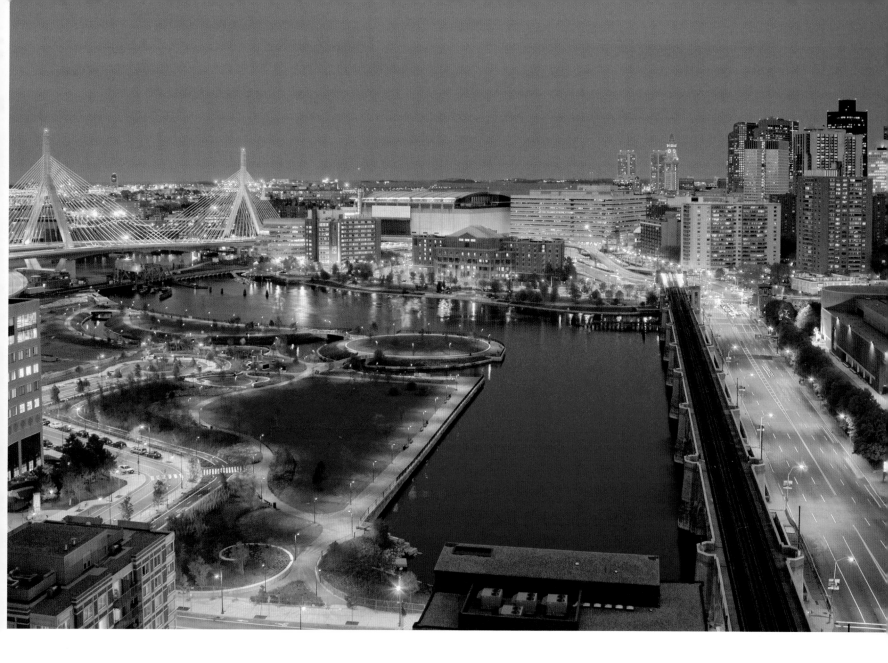

The Big Dig, which involved the construction of the Zakim Bridge, was the most expensive highway project in U.S. history. Although plagued by soaring costs, the Big Dig eliminated many of the traffic nightmares of the old expressway.

FOLLOWING PAGE: The Leonard P. Zakim Bunker Hill Bridge, seen here from City Square in Charlestown, is the widest cable-stayed bridge in the world. Opened in 2003, it was part of the Big Dig, a massive project that rerouted Interstate 93 through a 3.5-mile tunnel beneath Boston, eliminating the elevated roadway.

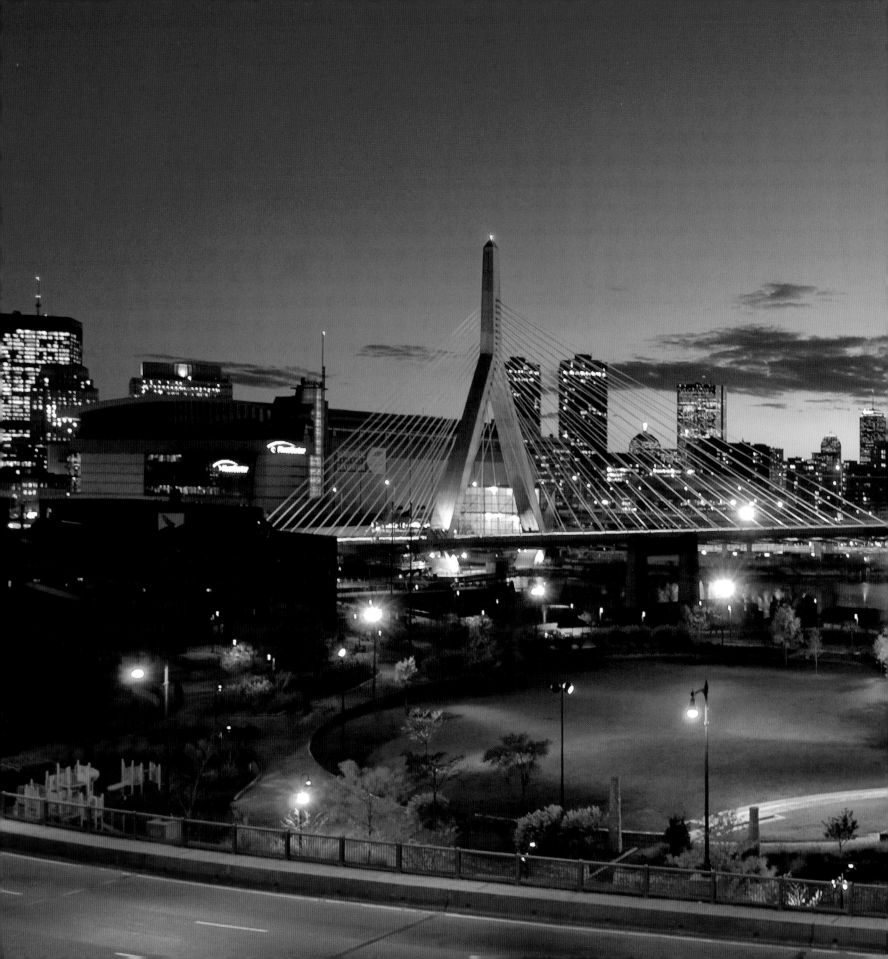

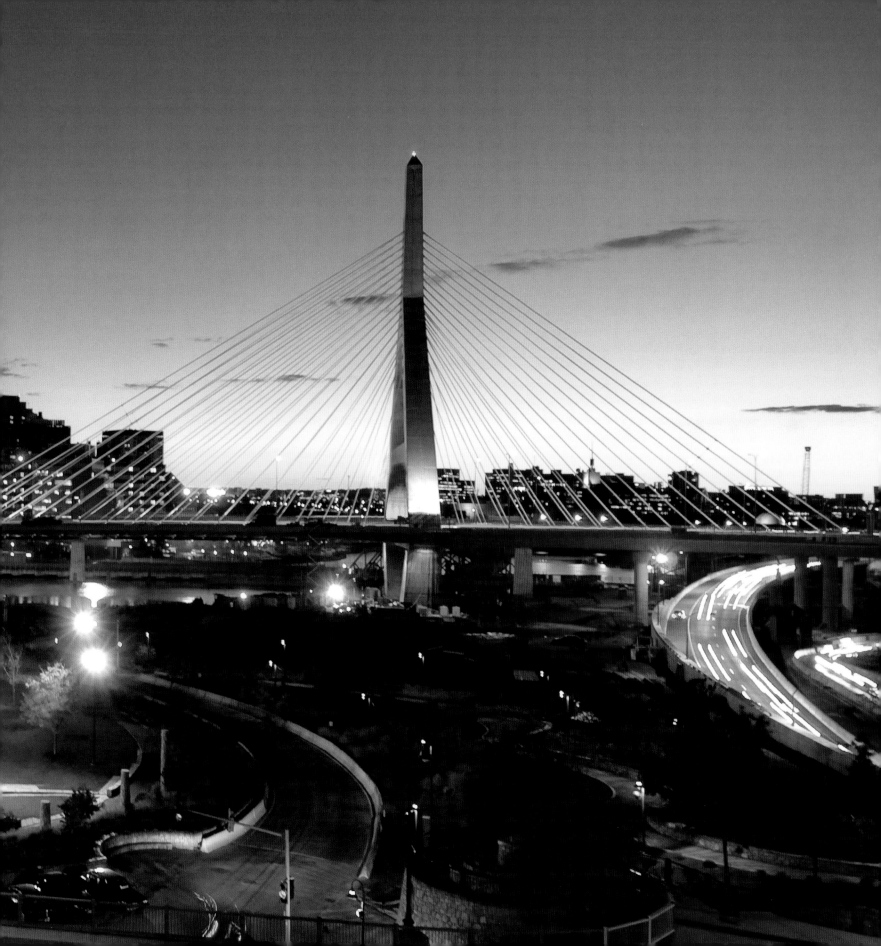